A–Z
OF
THE YORKSHIRE DALES
PLACES - PEOPLE - HISTORY

Mike Appleton

AMBERLEY

First published 2023

Amberley Publishing
The Hill, Stroud, Gloucestershire, GL5 4EP
www.amberley-books.com

Copyright © Mike Appleton, 2023

The right of Mike Appleton to be identified as
the Author of this work has been asserted in
accordance with the Copyrights, Designs and
Patents Act 1988.

ISBN 978 1 3981 1263 6 (print)
ISBN 978 1 3981 1264 3 (ebook)

British Library Cataloguing in Publication Data
A catalogue record for this book is available
from the British Library.

Typesetting by SJmagic DESIGN SERVICES,
India. Printed in Great Britain.

Contents

Preface

Cramming the breadth of the Dales into a handy 'cut and keep' A–Z guide is not an easy task. What to include, omit, go into detail about and scratch the surface of has tested the resolve of even this avid Dalesophile. Hopefully the pages within demonstrate my love of what I call my second home; the place in which I spend most of my time working and breathing. I've included some of my favourite dales and spoken to cavers, farmers and those entrusted with protecting this special place.

Of course, keen readers will note I've not included every dale within the Yorkshire Dales National Park, nor every mountain, or honeypot site. I hope you'll excuse this author for such a deliberate omission – I wanted to include as many seldom visited facets of the park as I could.

While writing this book I underwent some particularly tough times in my personal circumstance. Therefore, I am eternally grateful to the team at Amberley for their patience – Nick Grant, for one – and support. The people I interviewed demonstrated utter restraint too in waiting for their word to appear in print. I am truly humbled by you all.

I am also indebted to everyone who has helped me with pictures as my deadline approached. Mark Corner, you will never know how much I appreciate your photo library; Bill Nix for his excellent caving pictures; John Cordingley for his incredible support; and many others.

In no particular order I'd also like to thank: Sam and Ben Spence at Curlew Dairy; Alan Cleaver; Andrew Fagg for his dialect entry; Benji Grundy; Don Gamble for Hay Time, Rich Hore, Fiona Busfield, Sarah Hodgson and everyone at Yorkshire Dales Millennium Trust; Geoff Yeadon (diver of *The Underground Eiger*) and those that went before; Jamie and Amy McEwan, Tim Yetman and Catherine Bryan at Kingsdale Head Farm; my good friends Johnny Hartnell and Nigel McFarlane; Jamie Roberts at Kilnsey Park; Sharon and Peter Flint for their amazing knowledge of the Malham Sedge and the tour in the drizzle up at Malham Tarn; Iona Hill; Jane Robinson; Liz Lawton; Deborah Hall at Darnbrook Farm; Dr David Johnson; Tanya St Pierre; Geoff Garrett – you can now enjoy retirement!; Leanne Orrick for the X marks the spot idea; Peter and Ruth Kerr; Dave Kingstone; Renuka Russell; and David Joy.

<div align="right">Mike Appleton</div>

Alpine Bartsia

Alpine bartsia (*Bartsia alpine*) is uncommon to the Dales but has been discovered on Great Close Mire near Malham Tarn. It's hemiparasitic – being able to photosynthesise after gaining nutrients from a host plant. It's a hairy little thing, growing up to 20 centimetres, and flowers in June and July. It likes damp upland pastures and calcareous mires, making the niche climate at the tarn ideal.

Malham marks its southern limit geographically, but as we start to see more effects of climate change, it is feared that species like alpine bartsia will leave the Dales and only exist in more northerly climes.

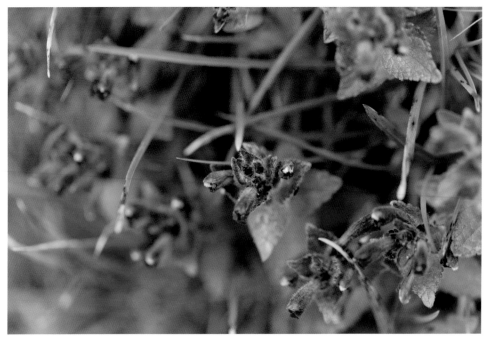

Blossoms of an alpine bartsia in a mountain meadow. (Shutterstock/ChWeiss)

Arkengarthdale

The most northernly of the Dales' national park and arguably one of the most picturesque. Much of this landscape has been altered due to lead mining and remnants can be seen all over this pleasant dale. It also hosted the filming of *All Creatures Great and Small* which told the life of famous vet James Herriot, whose real name was Alf Wight. Several episodes were filmed in Langthwaite.

James Herriot was a real advocate of the people and landscape of the Dales, and his legacy continues today. Through his daughter, Rosie Page, two barns were restored in Whaw (pronounced Whar) and Low Eskeleth, in partnership with Yorkshire Dales Millennium Trust and the National Park Authority. The park says that seventy to eighty of these barns need to be restored each year to 'properly conserve this special quality of the Yorkshire Dales National Park'. Farmers used these structures to house their livestock through the winter, collecting the manure to fertilise the land. In Swaledale in particular, there were a multitude that housed hay.

Sadly, restoring these barns isn't cheap; simple remedial work requires tens of thousands of pounds. At Whaw and Low Eskeleth, you can see the repaired structures as well as interpretation panels which detail their transformation. Specialist contractors have repaired roofs with existing slates, replaced doorframes and defective timbers and repointed using traditional lime mortar.

Across Arkengarthdale, as well as the park, several farmers are changing their practices to help fight the climate crisis. In 2018, Liz Sutcliffe sunk her savings to buy Heggs House in the dale. The 136-acre, off-grid site is a re-naturing project, which, alongside her neighbours, will help boost biodiversity. She said:

> Heggs is a little pocket of biodiversity within quite a stylised farming area. Heggs for whatever reason has been allowed to wild of its own accord. You've got a lot of pockets of woodland; Arkle Beck itself with all its intricate braids creating little island networks; you've got old tree lines and bits of wood pasture; bits of scrub winding up the hillside; a lot of secret shelter spots hidden behind crumbling stone walls; and wherever you get a vantage point you have amazing views up and down dale and they won't be obscured. And there's such a lot of birdsong.
>
> Together with my two neighbours we're 200 acres and that goes from the banks of the Arkle Beck up to the horizon which is the top of Fremington Edge and the moor line wall. Our big project was planting 74 acres of new broadleaved woodland (around 25,000 trees). We're trying to do this as naturally as possible and hopefully in the next twenty or thirty years we will have a very natural, open woodland with scrub around the edges – and that will join existing woodland corridors which exist on either side of our planting site. We also envisage restoring the remainder of the site to the wood pasture.

Liz Sutcliffe by Arkle Beck where alder trees are growing.

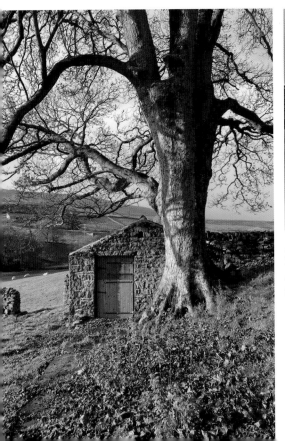

Left and above: The restored barns at Low Eskeleth and Whaw. The National Park Authority estimate that seventy to eighty of these need to be restored every year.

The new woodland was planted in the winter of 2022 and is publicly accessible. As well as providing vital habitat, it should help alleviate flooding by reducing the speed of rainfall runoff and consolidating the soil.

Aysgill Force

The honeypot sites of Thornton Force and Hardraw Force are ordained as such thanks to their spectacular setting and amazing geology. Yet, wander off the beaten track and there's some stunning smaller and seldom visited waterfalls that are well worth the muddy boots. Aysgill Force is one, which is located just outside Gayle in Sleddale and best approached by a beautiful circular from Hawes. Gayle Beck plunges 40 feet on its way to the River Ure, a waterfall you can hear long before it comes into view.

Barbondale

When the national park stretched its boundaries towards the north and west in 2016, it threw its arms around one of the region's real secrets.

Barbondale is a steep-sided valley, with the Dent Fault having a real defining say on what happens geologically above and below ground. You can see this crack by wandering up the track (SD656825) to Bull Pot Farm.

One of the best ways of taking in the valley is climbing up the oft-ignored Calf Top from Barbon village – and, more welcomingly, from the Barbon Inn. This hostelry began life as a farmhouse in the 1650s and those buildings are evident on its right-hand side. Walk towards St Bartholomew's Church in the village, turn left just after it and follow the road to a bend. Take the path on your left that heads around the outside of Ellers Wood to Eskholme.

Here, you have three different ways to choose but you're best passing through a gate and taking the path that goes right up the hill and onto access land. Follow this route – sketchy in places – past the cairn on Eskholme Pike (around SD640833) and then continue to the summit of Castle Knott. From here, continue onwards, dropping a little height, before ascending once again to the trig point on Calf Top (SD664856).

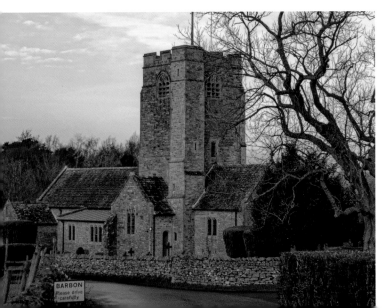

The small village of Barbon – a great way to visit The Calf... (Mark Corner)

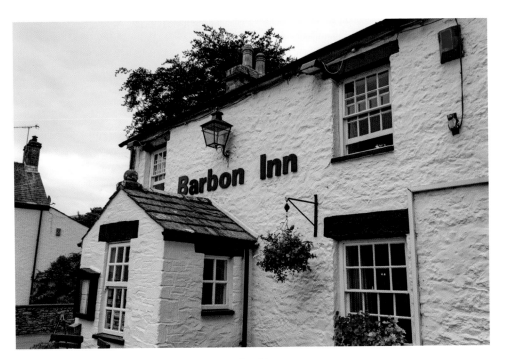

...Don't forget to pop in here when you come back!

Bishopdale

The little dale, some 7 miles long, contains some hidden gems as Bishopdale Beck runs through it on its journey to the River Ure. The small waterfalls in West Burton are well worth a visit, as is the quaint village of the same name, which hosts the largest village green in England, apparently. It's certainly sizeable; a large, octagonal cross governs its centre alongside stocks and bullring, indicating its prominence as a main market town for the area.

The village is home to the Cats Pottery where they have been making Moorside Cats ornaments since 1982. They open during the summer months for visitors to see the Nichols family make the cute felines. There's also evidence of an Iron Age settlement on top of Burton Moor – eighteen hut circles were discovered, and it's designated as a Scheduled Ancient Monument.

Elsewhere in the dale are the villages of Thoralby and Newbiggin. The former is probably one of the least well-known villages in the Dales. It lives in its own bubble away from the busier Aysgarth, just over a mile away. At its hub is the Grade II listed George Inn, a cosy pub built in 1732.

Thoralby derives its name from Thorald's Farm when the area was settled by Vikings. In the Domesday Book it is referred to as Turoldesbi. It also had a chantry chapel of All Hallows founded in the fourteenth century by Lady Mary Neville. Although no

physical trace remains, the name lingers on a row of cottages called Chapel Close and a house called Chapel Garth.

Newbiggin is a small village with its own Grade II listed pub: The Street Head Inn, which is nearly 300 years old.

Buckden Pike

Buckden Pike sits above Buckden village at 702 metres (2,303 ft). A walk from The Buck Inn, through Buckden Wood, offers fantastic views down the valley and can be combined with a circular that takes in Yockenthwaite Meadows and the charming The George Inn at Hubberholme.

The steady climb out of the national park's car park heads to Buckden Rake before turning right to the pike itself. South from the summit is a memorial cross, dedicated to the memory of five Polish airmen whose Wellington Bomber crashed on 30 January 1942. The plane took off from RAF Bramcote in Warwickshire on a training mission but ran into a snowstorm. The memorial was created by locals and sole survivor of the crash, Jozef Fusniak.

Descending from the cairn, you pass through some mine workings before coming back to the village and the welcome sight of 'the Buck'.

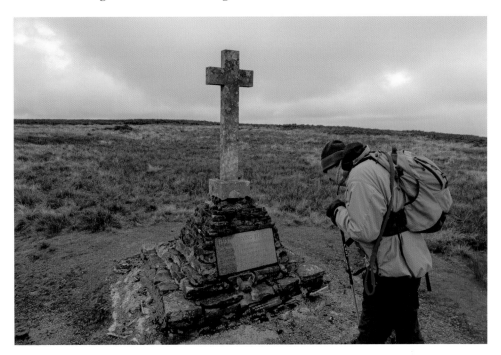

The memorial on Buckden Pike. (Mark Corner)

C

The CB Inn

Returning to Arkengarthdale, but this time to the superb Charles Bathurst Inn (CB Inn) and its homage to the family that made the dale a hive of activity. Charles was lord of the manor in the eighteenth century, opening several lead mines.

The CB (Charles Bathurst) Company was founded in 1656 when Dr John Bathurst, the physician to Oliver Cromwell, purchased the rights to mine in the area from the Crown. His descendants developed the mining industry, with Charles' initials ('CB') being stamped into the lead. This would be extracted by hushing – the controlled release of dammed water across a vein to expose the ore. There are some fantastic sites where you can see these hushes and spoil, as well as lines of bell pits with lateral tunnels or drifts along the vein. The lead would be sold to merchants based in York. The company continued mining in the area until 1911.

The inn itself, which heralds from the eighteenth century, is an excellent base for exploring this mining heritage and enjoying some great food and local beer. The local outdoor game of quoits is also played here from April to September. It involves the throwing of metal, rope or rubber rings over a set distance, usually to land over or near a spike.

Commoning

The Yorkshire Dales is a working landscape that has been framed by industries such as mining and farming ever since humans settled. One ancient agricultural practice is 'commoning', where farmers graze their sheep on common land in the uplands.

In the Dales, this method is somewhat threatened as areas of land are turned over for tree planting and natural regeneration. Historically, the commons were important as they allowed people to scrape a living by being self-sufficient on small areas of land, and then graze their animals on the uplands. As common land was enclosed to increase the efficiency of agriculture to feed a growing population, it was these local small holders who lost out.

Ingleborough graziers look for sheep during the gather as the mist lifts. (Rob Fraser/ somewhere-nowhere)

Nowadays, this land is owned by organisations such as the National Trust, the national park, utility companies or privately, and is effectively managed by graziers. It is thought there are more than 3,900 farmers who are commoners in England, with the Foundation for Common Land saying that 'each flock on the commons has a "heaf" (area of land) where they stay without fencing. This way of shared land management has protected some of the UK's most spectacular landscapes for a thousand years'.

The Dales is part of the £3 million Our Upland Commons project, which is helping to secure the future of this land as well similar sites in the Lake District, Dartmoor, and Shropshire Hills. Ingleborough is the focal point of the project in the south of the national park – as well as Grassington Moor some 30 or so miles away – whilst graziers at Brant Fell in the Howgills near Sedbergh also take part. In 2022, a dozen farmers and their dogs drove sheep on the west side of Ingleborough mountain into brand new sorting pens at Cod Bank, paid for by the project. It was the fifth and final gather of the year, intended to bring all the breeding ewes still on the fell to lower ground.

Cotter Force

Another beautiful waterfall near Hawes is Cotter Force, best viewed in autumn as the magical colours of the season are displayed along Cotter Beck. It's easily accessible too, being one of the national park's 'Miles without Stiles' walking routes.

Simply take the A684 towards Sedbergh and after crossing the River Ure on a narrow bridge, there is a lay-by on the right. A path here leads off to the waterfall – a walk of around a quarter of a mile, and accessible to wheelchair users.

It's easy to see why it is one of the most photographed waterfalls too. Cotter Force has six separate drops, each one wider than the previous, and is home to dippers, grey wagtails, redstarts, and kingfishers. It was also painted by Joseph Turner in 1816 during his tour of Yorkshire to collect material for the 'History of York' series.

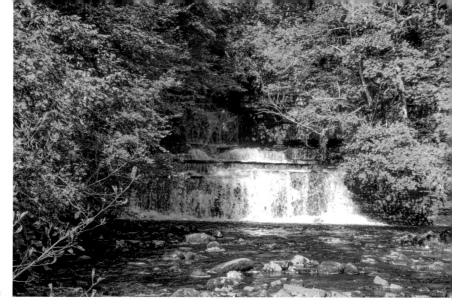

The beautiful
Cotter Force.
(Mark Corner)

Courtyard Dairy

During the pandemic several firms went online to fulfil the needs of people who didn't want to travel too far but retain access to quality local produce. There was a boom in buying 'local' and no doubt a deeper understanding of where food comes from and how important shopping in your community is to that place.

One business in the Dales, The Courtyard Dairy, near Settle, took advantage by hosting tasting sessions and webinars to showcase their quality cheeses. This was an obvious choice for Andy and Kathy Swinscoe, who have always moved with the times to ensure their dairy remains viable. So much so that at the time of writing a major expansion plan was underway with a new café and museum set to open later in 2023 alongside new maturation rooms.

Andy moved to the Dales after developing a real passion in fine foods and sourcing great quality cheeses. He hand-delivered cheese for Paxton and Whitfield, Britain's oldest cheesemonger, and then gained an award in 'Cheese Maturing' from the Queen Elizabeth Scholarship Trust, which enabled him to complete an apprenticeship in affinage (ageing cheese) in France with Hervé Mons. He eventually returned to England to work for Bath's Fine Cheese Company, sourcing cheese direct from farms. Kathy's knowledge of food is equally as impressive, having worked in fine dining in Edinburgh, and then in Bath for wine importer William Baber.

In 2012, they opened their own specialist cheese shop, The Courtyard Dairy, with an ethos of only selling the best cheese available from the British Isles and Europe. This initial enterprise was successful too, taking home a raft of awards. Five years later, the current Courtyard Dairy moved to its current home and really took off. They received grant support from the European Agricultural Fund for Rural Development and Yorkshire LEADER to buy and develop a former falconry centre into the 'cheese experience' it is called today.

Andy Swinscoe at Courtyard Dairy.

Coverdale

A quiet valley in Wensleydale, Coverdale has a mysterious edge. Starting close to East Witton, it runs towards Kettlewell and climbs Buckden Pike and Great Whernside, passing several moorlands in-between. Here, one route dissects Deadman's Hill, the site of a grisly murder that saw the discovery of three headless bodies in 1728. Then, there's the tale of Courting Wall Corner, a place no local would visit because they would see a ghostly figure of a mourning woman with a long black cloak who would shake her head in anguish. The story is based on a local girl who had to choose between two men and then elope to avoid scandal. The rejected fellow learned of her plans and duly killed and buried her on the moor – near Courting Wall Corner. To add weight to the story, peat cutters found a skeleton nearby wearing black clothes.

Close to Coverham is Forbidden Corner. Self-titled as the strangest place in the world, it is a cornucopia of oddities contained within a 'unique labyrinth of tunnels, chambers, follies and surprises created within a four-acre garden'.

Coverdale takes its name from the River Cover, which is of Brittonic origin. In the dale is the remains of Coverham Abbey, which was founded in the fourteenth century until its dissolution in 1536. It is Grade I listed but isn't open to the public.

It is also worth popping to The Cover Bridge Inn, which has been welcoming visitors for centuries. Previously called the Foresters Arms and the Masons Arms, it is situated alongside the River Cover, a few hundred yards upstream from the confluence with the River Ure and on the road from Jervaulx Abbey in East Witton to Middleham.

It is thought that this site may have been the hiding place of monks during the sacking of Jervaulx Abbey by troops loyal to King Henry VIII, and the scene of the first formally recorded game of cricket in 1706, which was celebrated some 300 years later with a team playing a touring side from Bahrain. Inside, the central T-shaped part was likely built in 1670, with further development right up until the eighteenth century.

Curlew Dairy

Old Roan Wensleydale is one of the few real farmhouse cheeses still being produced in the Dales. Unlike the traditional crumbly Wensleydale, it's smooth, buttery, and likely close to what Wensleydale used to, or should, taste like. It's acidic but mellows towards the rind. I'm attracted to this farmhouse cheese because of the sheer love and determination that goes into its production. Ben and Sam Spence use unpasteurised milk, it's clothbound with butter, and then aged for three to four months.

Their story is fascinating too. A few years ago they were able to take advantage of funding to diversify from a traditional method of milk production to a self-contained system that allowed them to sell their milk direct to the consumer and make cheese. Old Roan Wensleydale was launched in 2019 and it won a silver award at the artisan cheese awards in 2021.

In 2022, they were forced to leave their premises, and their herd, and set up from scratch. After investing so much time into getting the product right, they weren't going to be deterred by this monumental shift, managing to create a micro dairy at Wensley in just three weeks. And micro it is, being 18 square metres and located up in their garage. Incredible.

Obviously, one of the major issues was also leaving behind their family's herd, but they found a partner who had a small herd of Holstein and Ayrshire cows, which enhance the flavour of the cheese. They graze outside for most of the year and are fed on haylage made on the farm, in the winter. Sadly, the converted horse box in which the Spences used to vend their farm's raw milk and cheese is no longer open due to the economic climate; however, there is a little honesty box outside their dairy in Wensley where you can buy some cheese.

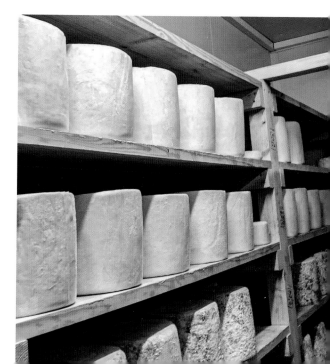

Old Roan Wensleydale maturing. (Sam Spence)

Dancing Flags

Dent is packed with heritage amongst narrow, cobbled streets that could be straight out of a film set. Just to the north of the village is Flintergill. Head upwards out of the village green to a steep climb that eventually breaks free to provide great views of Barbondale and beyond. The gill is also climbable for those more adventurous ... in dry weather, of course.

Just before the route lifts is an obvious path to the left which takes you to an open pavement of limestone, right in the gill itself. These dancing flags would have been a hive of activity in the eighteenth and nineteenth centuries as women pulped cloth on them with their feet.

Above: The dancing flags at Flintergill in Dent. (Alan Cleaver)

Left: The wishing tree further up the gill. (Alan Cleaver)

Dentdale

Dentdale is my favourite dale in the national park because of its views and memories of childhood adventures when on holiday. The River Dee was home to many a failed rafting attempt and trout fishing misendeavours, and, when I was legally old enough, the Sun Inn and George and Dragon were welcome watering holes following long walks and caving trips.

It is thought the dale was first settled in the tenth century by Norse invaders, but it's more than likely that Romans and ancient Britons were there long before then. Dent is the hub, but following up the Dee there's Cowgill, Dent station – the highest mainline station in England at 1,150 feet above sea level – and the impressive Dent Head Viaduct. It's also worth calling into the Sportsman Inn too, a sixteenth-century country inn.

Dent is a honeypot due to its chocolate box cobbled streets and charm. For such a small village, it has produced several important people and notable industry. Dent marble, a highly polished black limestone, was made here from 1760 to the early 1900s whilst the terrible knitters of Dent struck fear into those travelling by. Locals would supplement their income by knitting stockings, and for the Seven Years' War, between 1756 and 1763, the government placed agents nearby to secure the 'worsted stockings' for the English army. The garments produced were of great quality due to the wool, and they could be made quickly. In 1801, it was recorded that an average of 840 pairs of knitted stockings came from Sedbergh and Dent. Gloves and hats would also be made and sent by pack pony to Kendal and beyond.

The 'terrible knitters', as they were known, worked in clusters and had a reputation for being great gossips. 'Terrible' refers to the ferocity in which they knitted, but also the way they would rock back and forward whilst removing the loops.

Adam Sedgwick, a founder of modern geology, was born in Dent and held it very close to his heart. He proposed the Devonian and Cambrian periods of timescale and worked with the young Charles Darwin in his early study of geology.

Then you have the Dent Vampire. Outside the porch of St Andrew's Church, which was built in the twelfth century, is the gravestone of the George Hodgeson. He died in 1715, aged ninety-four, but started to make regular appearances around the village. Folklore suggested he downed a daily glass of sheep's blood as a tonic, which might have positively affected his longevity, and a farmer said he had shot a black hare and followed the blood trail, which led to George's door. Worried, villagers exhumed his body, dug a new grave at his door and drove a brass stake through his body. You can still see the top of that 'stake' in the upper part of the gravestone too. However, the remains of the stake are nothing more than a brass plaque that had been attached to the stone.

For a fantastic view of Dentdale – a real 360-degree panorama – I'd recommend walking part of the Craven Way, an old packhorse route that connected Dentdale to Ingleton. Approach from Ibbeth Peril, near Cowgill, as the way from Dent itself is laborious. There is a sizeable parking area at Ibbeth Peril, which is an extensive cave system set in the River Dee.

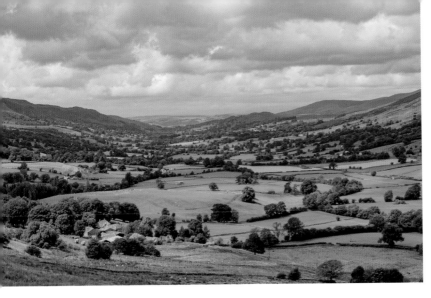

View of Dentdale
from the Craven
Old Way.

Dialect

At a Grassington Festival lecture in the early 1980s the last dialect poet of Upper Wensleydale, Revd James Alderson, said that dialect was doomed. His judgement was sound. In the forty years since, the old twang has continued to disappear.

One of my grandad's greatest boasts was that as a lad he was 'cock o't school' in Hardraw. Today's generation would only giggle at such a phrase. For them it's about who is the 'hardest'. It's a battle even to get my daughter to use the word hen. They're all chickens to her.

You don't hear of anybody 'grobbling', or tickling, for trout anymore, either. Perhaps that's because, as the anglers in Upper Wensleydale say today, there are 'no fish int beck'.

And yet dialect survives in a phrase here, a word there. Old women still 'toddle'. Children picky with food are still occasionally called 'kystie'. After a big meal I am fond of declaring myself 'brossen'.

Old pronunciations also linger. I was at Gayle Chapel on Sunday night and I'd hung my winter coat in the porch. An old member called Alan lifted it down for me as I left at the end of the service. 'By that's a heavy ko-aat,' he said. One syllable words such as boat or door are still made into two, as in 'bo-aat' and 'doo-er'. Also, it's never cold. Rather it's 'cowd'.

Farming families probably use what's left of dialect more than most. Go to Hawes Auction Mart today and you might see the seller of lamb's hand, a coin or two to the buyer. 'I'll gi thee a bit o'luck,' he says. 'Luck money' is a bit of 'brass' back on the official purchase price.

The only way that dialect will survive is if people speak it. So please, let's not talk about rams and ewes ('yews'). Long live the tup and the 'yow'.

Written by Andrew Fagg from Hawes.

E

Ease Gill

Stretching some 90 kilometres, the Three Counties cave system is British caving's jewel in the crown. For a long time the thought of physically connecting passages across Yorkshire, Lancashire, and Cumbria has been the work of ardent mud lovers who stoically toiled in tight passages to make breakthroughs and extend the system. But the thought of making a Three Counties trip itself was the stuff of folklore.

Such a journey would see the explorer undertake many dives in brown, peaty water and negotiate a multitude of dry passages. They'd also need to be fit as a fiddle to climb and descend ropes, and have a team of like-minded speleo fans to provide back-up support.

On 25 September 2021, two cavers did just that. Jason Mallinson and Chris Jewell entered Large Pot, next to the Turbary Road between Ireby Fell and Kingsdale, at 11 a.m. to traverse the system through to Top Sink in Ease Gill. The preparation to complete such a task was immense. Some of the connecting dives had never been completed as a through trip – having been dived from the opposite side – and new routes had been discovered. Then there was the sheer number of climbs and pitches that needed to be pre-rigged. Transporting gear was a mammoth task.

Yet, the hardy duo completed the trip at 4.30 a.m. the next morning and added their names into the annals of caving history. They received a beer as they came out of Top Sink but there was no celebration; a simple nod between those gathered at a job well done. Cavers can be a quiet, brooding species sometimes.

Visiting Ease Gill you won't get a sense of this achievement – the realisation of a life's work for some. Bull Pot Farm is the headquarters of the Red Rose Caving and Pothole Club (RRCPC) and a few metres down the track is Bull Pot of the Witches, a large enveloping hole that takes an active stream. Further along the track, most of the activity is below ground but walkers can get glimpse of what could be. Beyond the first wall on the route, turn left and you can view Cow Pot. It's pink limestone walls descend some 23 metres and link up with other parts of the Ease Gill system. A few metres from this pothole is Lancaster Hole – its discovery by George Cornes and Bill Taylor in 1946 unlocked the system for more exploration.

The walk from Lancaster Hole takes you down to the dry riverbed and a place of silent reverie where heather, bracken and trees all grow without human intervention.

It is serenely peaceful. Following the stream bed to the left, you go past several shafts before you reach Cow Dub and the beautiful waterfall encased in rock. Climbing up the right-hand side you come out into Ease Gill itself, with its litany of cave entrances, fossils in the stream bed and interesting rock shapes carved out by the water. Following the Ease Gill Beck downwards, you can reach Ease Gill Kirk: a limestone ravine with upper and lower sections that feature a multitude of caves, grottos, and a U-shaped waterfall with cliffs on the left and right.

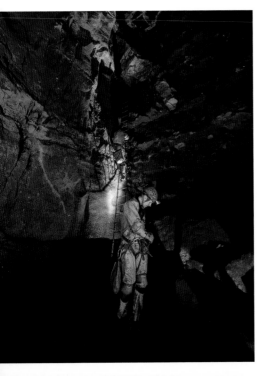

Left: Equipment being checked at Stop Pot on the Three Counties Traverse. (Bill Nix)

Below: Humble celebrations! (Bill Nix)

East Gill Force

This lovely waterfall can be viewed on the circular walk from Muker and Keld. It's around 300 metres east of Keld just before it meets the River Swale. Having two falls, the upper is around 4.5 metres high and is very popular with dippers and other birds, whilst lower down is a stepped cascade. A little further on is a hand line, which helps you descend the slippery and often muddy path to Kisdon Force – an absolute cracker of a vista whatever the weather.

East Gill Force can be seen on a circular walk from Muker. (Benji Grundy)

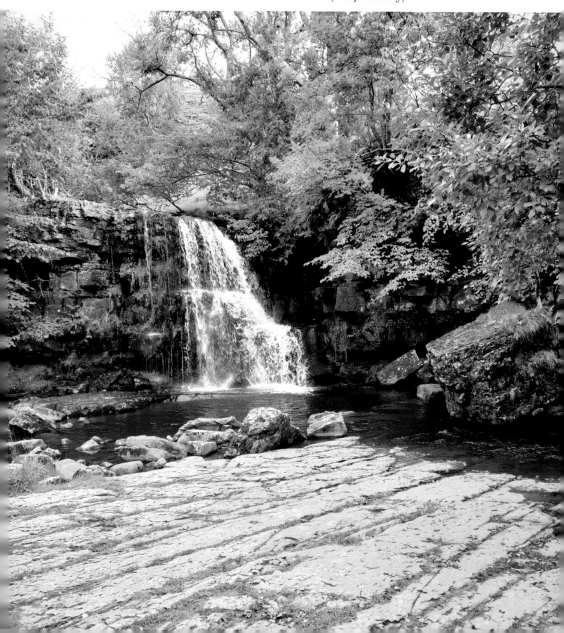

Farm Shops

As with any food-led business, owning your story is the best way of connecting people with your produce. That tale – why you make your cheese or farm in a certain way – is the link between the speciality of the product and the run-of-the-mill stuff your local supermarket could sell. Several attempts have been made to show 'farming to fork', the connection between how our food is made, but one of the best ways is simply being able to purchase it right on site.

The Dales has a smattering of farm shops which allow visitors to get as close as they can to hyperlocal produce without donning overalls and boots to make it themselves. Two stand out: Keelham's in Skipton, opened in 2015, and Town End in Airton, run by fifth-generation butcher Chris Wildman, who makes his own chorizo.

Just at the junction of the A59 and A65 in Skipton (next to the auction mart) Keelham's is supermarket in size but certainly not in feel. They support more than 250 suppliers from the region with the ethos that if they look after them, then the local economy is stronger too. There's an 'eco' feel as well; local food means less food miles, there's hardly any plastic wrapping, and you can fill up your own containers.

Town End is a little more rustic in its façade – it is a farm shop in the true sense of the phrase – but equally as supportive of local produce. It's based on the Malham road out of Airton in Malhamdale, some 5 or so miles from Settle. It has a plethora of food on sale – award winning charcuterie and salumi, for instance – and the mandatory tearoom, as well as offering butchery courses if that takes your fancy. The owners breed their own grass-fed lamb, cattle, and rare breed pigs.

There are several other farm shops in the national park that are worth calling into, including Jackson's of Cracoe in Wharfedale, which sells locally sourced meat. We mustn't forget the minute outlets too: those mini shops selling products right at the farm itself. Across the park are honesty boxes filled with eggs, cakes, cheese, and other great items that it should be made criminal to ignore or drive past. One of my favourites is at Newby Head, on the road to Hawes from Ingleton. Signs leading to it simply say 'homemade cakes'. Just pull over and get one. You won't regret it.

Farrers

In the south of the park, the village of Clapham played host to a family that not only helped to enhance botany on a world stage, but who also set the scene for rural community housing we see today.

The Farrers established Ingleborough Estate in the eighteenth century and are responsible for most of the outstanding beauty around the village. They also initiated social policies that meant local families could live in the village, ensuring it remained viable and a reflection of a real rural community. They did this by offering affordable rents and making sure families were higher up the waiting list when a house became available.

The most famous Farrer was Reginald, a world-renowned botanist who from his birth in 1880 to his death forty years later loved landscape, exotic plants, and travel. When he returned from his trips, he would sow his collected seeds and botanical species in the family's grounds. He was particularly drawn to alpines, shrubs, and other plants that he would find in China, Tibet, and Burma.

Reginald was canny too. Worried that his collections might not grow as they should, he found a novel way of ensuring they'd germinate. Getting into a small boat, he would row over a lake in the grounds, load the seeds into a shotgun and fire them into the nearby cliffs! It is well worth seeing his work on the Nature Trail in the village, which was established in 1970 to celebrate his life. The walk opens out to the artificial lake where Reginald would launch his cliff stalking activities – the body of water providing power to streetlights hydroelectrically, said to be the first such scheme in the country at the time. The trail then continues up to Ingleborough Cave and eventually to Gaping Gill and onto Ingleborough's summit.

Clapham, home of the Farrers.

Gamelands Stone Circle

It may be a shadow of its former self, but this stone circle, which stands at the base of Knott Scar, about halfway between Orton and Raisbeck, is one of the most tranquil places in the national park.

Dating from the middle to late Neolithic, its thirty-three stones create an oval shape of 44.5 metres by 37.5 metres, and none are higher than around 1 metre. It is thought that it once contained forty-three, but the land was ploughed in the 1860s and the stones pulled to the ground, buried or even blown-up with gunpowder. As a result, most of the southern arc is missing. All but one is pink granite with the lone exception a single block of limestone, which could have come from 'a central burial cist', according to stone-circles.org.uk.

Artefacts found on the site date from 1800 to 1400 BC.

Gamelands Stone Circle. (Andy Kay – Yorkshire Dales National Park Authority)

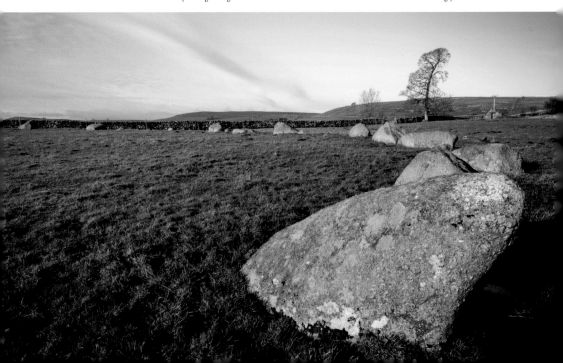

Garsdale

Right at the top of the Dales, with large parts in South Lakeland, sits Garsdale, a sweeping valley that takes in the Pennines, the south eastern part of the Howgills, and Sedbergh to the west.

The most scenic route through the dale is the coal road, which connects Garsdale to Dent station. It's single-tracked and offers amazing views, but is best avoided in winter due to its remoteness.

It's also worth noting that the famous Settle–Carlisle railway line goes through the top of the dale at the wild Garsdale Head, a station that features a quirky statue of Ruswarp, a collie that Graham Nuttall (the first secretary of the Friends of the Settle–Carlisle Line) owned. The dog's paw print appeared on a petition against closing the line as he was a fare-paying passenger.

Sadly, both Ruswarp and his owner went missing in the Welsh mountains; Graham's body was eventually found. Ruswarp was carried off the mountain, weak and exhausted, after staying with his owner for eleven weeks.

Giggleswick Quarry Caves – 'Goners'

As the Dales evolves, it's inevitable that pieces of cultural and historical heritage will disappear, but there are lots of organisations trying to preserve the past. So much so, the Dales has often been called a museum where progression and advancement don't seem to fit with most people's view of a national park. That is open to debate, but there are plenty of reasons why millions flock to this part of Britain's countryside every year, and a large one is to connect with the past and those that have gone before them.

Sadly, some progress does have an impact. Quarries in particular leave a legacy on the landscape that cannot easily be returned to the way it was by planting a few trees and letting nature take over.

Giggleswick Quarry, near Settle, was closed nearly fifteen years ago after its reserves had been depleted. It was put up for sale by Hanson UK in 2016. The reason why this landmark features here is because of what has been lost – caves. Any quarry that takes limestone is likely to be removing natural features that have taken millions of years to form.

That said, you could also argue that if it wasn't for quarrying, and indeed mining activity, some of these caves wouldn't have been discovered in the first place.

In 1931, the Craven Pothole Club made its first descent into the quarry to check out what was called Giggleswick Quarry Cave. A year later the Yorkshire Ramblers Club's journal said that 'during the summer a small cave was broken into the face of Giggleswick Quarry, and by now is probably quarried away'.

Fifty years later the March edition of the *ULSA Review* reported:

> During the blasting of the quarry face, a large cave was exposed. The cavity was 150 ft. long with maximum dimensions of twenty-five feet wide by thirty feet high. Ends in a choke seventy-five feet above the quarry floor and the continuation must be below the rubble at the entrance. Undoubtedly more caves may be expected as the quarry face advances.

Eminent caver John Cordingley told me that the original *Northern Caves V1* publication said that Giggleswick Quarry Cave was quite big by all accounts. He said: 'The map in *Northern Caves V1* shows it being on the [east] side of the quarry and says it's likely to be quarried away. But the quarry is much bigger than that map shows. There are the partial remains of a big natural passage on the left (west) side – I always wondered if that was what was left of Giggleswick Quarry Cave – perhaps the position shown on the *Northern Caves V1* map may be wrong or it could be the remains of a completely different (big) natural cave, found and largely destroyed subsequently.'

An updated version of *Northern Caves 2: The Three Peaks* was published in 1991 and it described the cave as 43 metres in length: 'Large entrance exposed by quarrying opens into huge chamber, twenty-four metres long, eight metres wide with various holes in the roof' ... it then repeats ... 'liable to be quarried away'.

There are several other caves on Giggleswick Scar that have been documented and are still there. There are also those that are being rediscovered and pushed further. Saga Hole, for instance, is around 48 metres in length. Away from the quarry is Greater Kelco Cave, which was extended in late October 2022 by John. These two aren't accessible to the public.

It's sad that this heritage and landscape is lost by progress – one caver said to me 'that's life lad' – and therefore it's important that we document as much history as we can for future generations.

Giggleswick Scar.

H

Hay Time

Of the many wonderful habitats and landscape features that the Dales are renowned and loved for, it's the flower-rich hay meadows that are top of the list for many. Stunningly beautiful from spring through summer and providing food and shelter for a host of wildlife, they're also rich in folklore and tradition and an important part of our rural heritage – a living and vibrant link to the past.

For centuries they were an integral part of farms throughout the lowlands and upland fringes of Britain, their sole purpose being to produce a hay crop to sustain livestock through the winter. Generations of farmers carefully and consistently managed them through an annual cycle of grazing and a late summer mowing, relying on the sun and wind to dry the crop, with only 'muck' being spread to maintain the soil's fertility.

And linked to the meadows is another Dales specialty: the stone-built field barns, dotted throughout the Dales, built originally to provide dry storage for the hay crop and winter shelter for livestock.

The Dales is one of the few strongholds for the country's remaining traditionally managed meadows, largely because farmers and landowners have been encouraged and supported to continue to manage them as their predecessors did, in recognition of the benefits and value that meadows have for people and wildlife.

The cooler, wetter climate of the upland landscape of the Dales results in a particular suite of meadow plants: wood-crane's bill, melancholy thistle, globeflower, great burnet, marsh marigold, pignut, lady's mantle, eyebright, rough hawkbit, and meadowsweet, along with less-picky plants like yellow rattle, cat's ear, knapweed, red clover and, of course, meadow buttercup.

One of the best places to see a colourful meadow in June is at Muker, the quintessential Dales village in Swaledale. A flagged footpath leads through three meadows, enabling close-up and personal contact with these astonishing places. About half a mile east of Muker is Yellands Meadow, owned by Yorkshire Wildlife Trust but with public access.

Go on a summer's morning and imagine being back in the day: the evocative smell of freshly cut grass, the clink and clatter of the Clydesdale-drawn machinery, the banter of the Irish labourers taking a break from scything and raking at the mid-morn

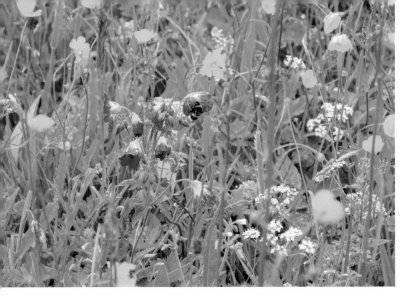

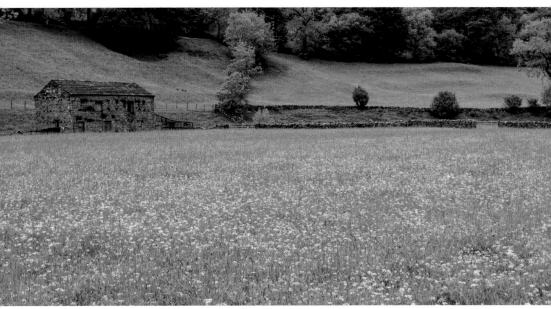

Left and below: The flower-rich Muker meadows.

'drinkings', and the farmer's relief of getting the crop safely into the mew before the threatening storm breaks.

Written by Don Gamble.

Hen Harrier

The Dales has two well-known birds of prey – the peregrine falcon and the hen harrier. Yes, there are plenty of kestrels, buzzards, sparrowhawks, and even red kites in the area, but this duo are standouts.

The hen harrier was formerly a widespread breeding bird throughout lowland and upland heathland, but after its habitat became smaller and more fragmented it retreated to the western isles of Scotland and Orkneys. It made a welcome return to northern England in the 1960s as its population grew, but sadly it seems that this much-loved bird is now having its habitat restricted once more.

Hen harriers are legally protected, yet many organisations cite that illegal persecution has meant the population is unable to expand, as it once did, in northern England. The park says that proving this is difficult but have been looking at 'the number of pairs there could be, and the number of pairs that actually breed'.

The Joint Nature Conservation Committee (JNCC) *Hen Harrier Framework*, published in 2011, determined that there was enough suitable nesting habitat in northern England to support between 323 and 340 breeding pairs. In 2018, the population was limited to only nine successful nests out of fourteen breeding attempts, with thirty-four chicks fledged. Three years later, Yorkshire Dales Bird of Prey Partnership revealed one of the most successful hen harrier breeding seasons in the Yorkshire Dales since they first returned to breed in the 1960s. Seven nesting attempts fledged twenty-six hen harrier young, representing 43 per cent of the recorded fledged hen harrier chicks across the north of England in 2020. The report also confirmed ten persecution incidents were recorded in the park and Nidderdale.

Hen harriers are under pressure. (Dennis Jacobsen)

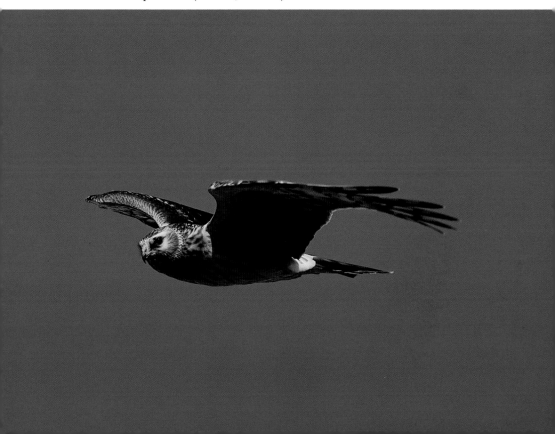

Finding a balance between country sports and bird of prey conservation is clearly a difficult act, but the park has included it in their management plan. They want to 'work with moorland managers and other key stakeholders to devise and implement a local approach to end illegal persecution of raptors, including independent and scientifically robust monitoring, and co-ordinated hen harrier nest and winter roost site protection'. Yet, prosecutions are few and far between when it comes to raptor crime and that leaves efforts to increase the population of this fantastic and iconic bird somewhat diminished. Hopefully, a balance can be found, and the Harrier's spectacular sky dance can be one we can all enjoy well into the future.

Hexagonal Powderhouse

This strange-looking structure is close to the CB Inn in Arkengarthdale. It was built in 1804 to house gunpowder and dynamite for use in lead mining. The idea – or hope – was that the building's structure would help in the event of an explosion, but even so it was located well away from all the other buildings that administered the mining operations, and the fuses weren't there either.

Ironically, even though these safety procedures were in place, it seems that locals put pressure on its owner to have the combustible stuff placed elsewhere on the moor. Looks great though, doesn't it?

Designed to stop a big bang getting a lot bigger!

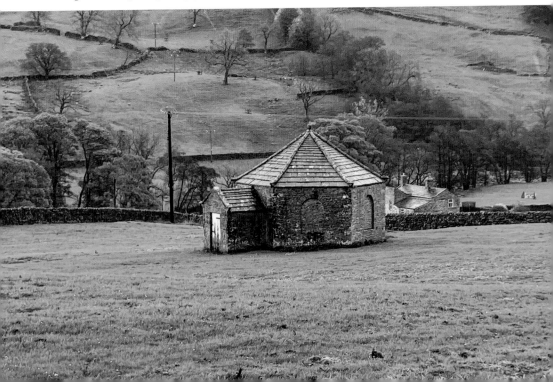

Hoffman Kiln

Built in 1873, the Hoffman Kiln at Langcliffe was constructed for the Craven Lime Company to provide lime for farmers to reduce the acidity of their soil, mortar for construction, tanning, textiles, and in paper. In use until 1931, it had twenty-two separate burning chambers and was lined with firebricks to maintain heat. These were insulated by limestone rubble which allowed that temperature to remain as hot as possible. The kiln would be filled by hand, with workers stacking limestone and adding coal, each chamber taking up to five days before it was full.

Once lit, crushed coal would be dropped into the chamber through small chutes, whilst flues in the walls allowed air to circulate. These were controlled from the roof meaning heat could be regulated, and as one chamber burned, its neighbour would warm too. Ingenious.

Not all chambers would be in use at the same time as some would be allowed to cool so lime could be collected and placed on railways outside to be transported away. Backbreaking and dangerous work. The lime would be rock solid and broken up, by hand, in very intense heat.

The Hoffman Kiln at Langcliffe, inside and out.

The kiln is just north of Langcliffe, on the B6479. Simply go under the small railway bridge on your right, follow the road round and turn right at the junction into a car park. It's a magnificent place containing railway sidings, tunnels, and other workings and, just to the top left, a walk down some steps reveal a rival company's kiln.

Howgills

I have a love-hate relationship with the Howgills. Firstly, on many a trip up the M6, reaching these rolling hills meant I wasn't going to be visiting the Dales and would more likely be dragged around various tea and gift shops in the Lakes. Secondly, they are just so bland, aren't they? Sparse of any trees and seemingly, life. I'd say my dislike often descended into an obsession until I actually bit the bullet and went wandering.

Yes, it's still pretty featureless for the tree lover, but there are some real gems to be found. The Calf is a cracking climb and, at 676 metres (2,218 feet), gets some work into your legs and rewards with good views. Then you have Cautley Spout, England's highest cascading waterfall above ground, as Cautley Holme Beck falls some 200 metres down the fells. There are also several other hills nearby and the town of Sedbergh is a good base. I've warmed to it ... and I have to really, as in 2016 a large chunk of the hills Wainwright described as 'a herd of sleeping elephants', finally became part of the national park.

Cautley Spout in the Howgills, England's highest cascading waterfall above ground.

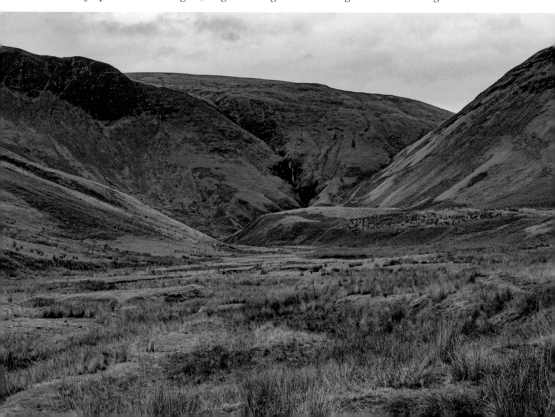

I

Ingleborough

There probably isn't a more iconic summit in the whole of the Yorkshire Dales, and in Yorkshire, than Ingleborough. Its plateau can be easily spotted in the distance and attracts far more people than its Whernside and Pen-y-Ghent siblings. At 2,372 feet, it is capped by millstone grit that is more than 320 million years old.

Its summit may have housed an Iron Age fort, which was probably built in the first century AD by the Brigantes as they looked to defend against possible Roman attacks. Archaeological digs have revealed a 'rampart' made from the grit, and foundations of circular stone huts. Some have suggested that these could even be Bronze Age in origin, and there is a theory that as the rampart takes several separate forms, it might not have been a defensive structure after all.

With caves, fantastic limestone scenery, and stunning views it's clear why Ingleborough is so popular ... and that makes it difficult to have it to yourself, you selfish lot! However, it is possible with a bit of planning and an early alarm call. Walk up from Clapham at sunrise and you won't meet anyone until you return. The route up from the Hill Inn at Chapel-le-Dale is long and therefore quiet too – and it passes Southerscales, a wonderful limestone pavement. Reversing the traditional Three Peaks route and climbing up from Horton-in-Ribblesdale is another route seldom used. Then there are routes from Newby and Cold Cotes on paths that are difficult to follow as they haven't seen many boots.

The summit is often covered in mist, so please take a map and compass and know how to use them!

Ingleborough with its
winter hat on.

Just Inside...

...the national park is Great Whernside, not to be confused with the Whernside that's part of the Three Peaks. It sits at 704 metres (2,310 feet) and is on the boundary with Nidderdale AONB. It's best approached from Kettlewell or, for those more adventurous, from Scar House Reservoir where you can follow the River Nidd to its origin. Interestingly, studies of OS maps have found that Whernside was the original name for the hill in Wharfedale, with the view from Nidderdale known as Blackfell. 'Great' was added in 1771, no doubt to distinguish it from Little Whernside, which is just a couple of miles away.

Below and opposite: Great Whernside summit in winter – what a view! (Rich Hore)

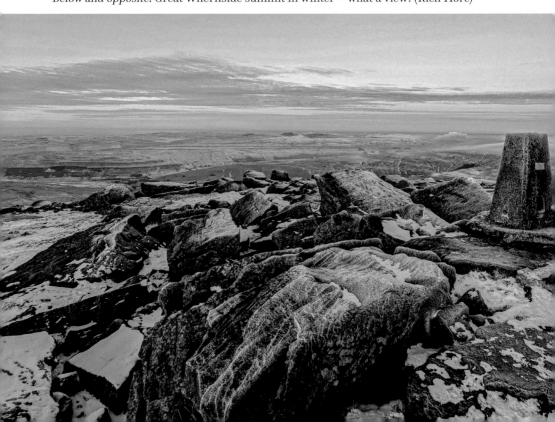

Keld Head

Although most of the planet has now been explored, there are still pockets of regions that lay bare to the advance of humankind. Everest was climbed in 1953 – perhaps 1924, if George Mallory or Sandy Irvine's camera is ever found – and recently Nepali geographers claimed there were a further six 8,000-metre peaks in the country, taking the total over that height to twenty.

In 1979, divers in Kingsdale attempted to complete the 'Underground Eiger', connecting the Kingsdale Master Cave to the resurgence at Keld Head. This would be a dive of 1,829 metres, the longest in the world, and the culmination of close to five years' work. On 16 January 1979, Geoff Yeadon and Oliver Statham (aka Bear, who sadly passed away at the age of twenty-seven) linked the system with a dive that took around two-and-a-half hours, filmed by Yorkshire Television, and eventually broadcast to millions. It was an incredible feat.

Geoff Yeadon is still a very active caver, particularly in exploring and pushing new passages, and is a legend in cave diving. He has set many records for longest dives and made the connection between Gaping Gill and Ingleborough Cave. He recalls:

> We began surveying Keld Held in 1975 and were adding line to our existing exploration but never really felt we were getting closer to the Master Cave. On 4 July 1975, we found Alan Erith in passages close to the entrance. He had been lost since 3 October 1970. That was a tough recovery because he had been there so long. In the process, a fellow diver found a loop passage, parts of which had been known by various people but until I started surveying nobody knew it was a continuous loop. Initially I tried to memorise compass bearings, but this clearly had limitations. With this in mind I constructed the first forearm-mounted writing slate on which to record bearings and depth readings between measured tags on the guideline. A tethered HB pencil completed the kit.

Subsequent explorations pushed the main passage further, and in 1976 the duo started looking at connecting what they'd found from the downstream sump in Kingsdale Master Cave. Two years later, Oliver invited experienced German cave diver Jochen Hasenmayer to join the exploration. Jochen dove the upstream sump but came to a tight section of

passage and was convinced he'd missed something. He brought in the line he had been using and looked around for another route. He then passed the constriction and moved up the stream. Oliver, on the other hand, made the decision to turn around because he couldn't follow the line as it wasn't secured and had pulled into a lowering to the side. He was faced with an impossibly low bedding through which no one could follow and, even more worryingly, no one could return. As he retreated down the line, he met Geoff and wrote on this friend's slate: '3000, small with back and side, No Jochen, Trouble?'

Geoff opted to go and find Jochen and met him at what was later to be named Dead Man's Handshake, around 914 metres into the system. He said:

> Thank goodness I had made that slate three years earlier. Without it I don't know how Bear could have relayed his message. I felt the line twitching and it was obvious that he (Jochen) was in trouble. I replied by tugging on the line to let him know I was there and then he came right alongside me, with his head on one side, and having failed to squeeze through the lowering between us, returned into the gloom.
>
> Visibility was bad, so he didn't see me. He then appeared at a small hole, nowhere near where the line was. I shoved my hand in this hole and he grabbed it. His hand was shaking like a leaf and that isn't something you can ever forget. I felt sad, like I was shaking the hands of dead man; he wouldn't be able to get out as he was low on air. I tried to give hand signals, telling him where he should go but this proved impossible as we were on the very limit of our reach. He then patted me on the back of my hand as if to say he was going to have another go. Thankfully, he got out because I felt he must have had very limited air left in both of his tanks having been underwater for forty-five minutes longer than me.
>
> The whole episode was twenty minutes of absolute tension and much of the time I endured an almost overwhelming emotion that I would be returning to the surface alone. His situation was so bleak with no clear solution.

It seems that Jochen passed the constriction before veering right towards a bedding plane. As he hadn't fastened his guideline down, it got dragged into this passage. On his return, he naturally followed the line, but it was impossible to find the way out because of poor visibility. Hasenmayer's view of the account varies, as he claims he wasn't panicking because he had enough air, but the important thing is that both divers lived to tell the tale. Geoff says the constriction is now a little easier to pass too because he has dug it out by hand, making the journey much easier.

From there, Geoff realised that the breakthrough was very close. He constructed a side-mounted harness to hold four cylinders, which meant he could get through the constriction and pass the limit at 1,006 metres that Hasenmayer had made. In 1978, he pushed to within 60 metres of the connection and then on a separate dive from the upstream end found and descended a shaft to a depth of 18 metres – the same level as the Keld Head dive.

The final linking of the system saw each diver making their own attempt, effectively waiting for the other to return before they gave it a try. Bear reached 1,097 metres and

came back before Geoff made his own run. He pushed through 'Dead Man's Handshake' and then progressed until he hoped to see an orange diving line placed from the Kingsdale side of the passage. After a short while he found it, connected the one he was using and headed back towards Keld Head. Job done – but sadly without his follow divers who had made this possible. That made the final 'confirmation' dive a possibility. Bear filmed the trip with two cameras and Geoff maintained radio contact. This type of communication from a diver, through water and 100 metres of rock to the surface, was another world first.

It's hard to believe that nearly forty-four years ago sleepy Kingsdale was the height of pushing the boundaries of exploration, with divers emerging from deep murky waters and a film crew on hand to see it all. As Geoff and Bear came out of Keld Head, a few champagne bottles were uncorked, and a beer thrown their way. It wasn't overly dramatic, just recognition of the hard work that had gone into it.

The dive was a world record at the time and remained a record in the UK until it was broken in 1991.

The unassuming sump entrance at Keld Head.

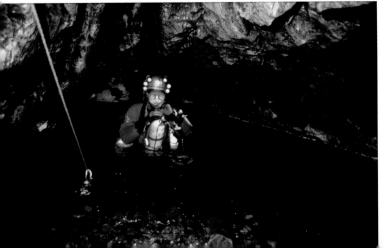

John Cordingley at the downstream sump in the Kingsdale Master Cave. (Dave Kingstone)

K

Kingsdale Head Farm

Kingsdale is one of the national park's most remote valleys. Sited on the western edge of the park, it borders part of Cumbria as well as Whernside to the east and Gragareth to the west. It is a working landscape, predominately shaped by sheep and sadly bereft of the green tree-lined pastures of its Dentdale neighbour.

In-between Ingleton and Dent, along the road out of Thornton, is Kingsdale Head, a farm covering 1,503 acres of archetypal upland landscape. For years it was a traditional hill enterprise, grazing more than 600 sheep amongst well-kept fields, and on the open fell itself. The previous farmer had reduced sheep grazing in 2011 as part of a Higher Lever Stewardship Scheme.

In 2020, it was sold to Catherine Bryan and Tim Yetman who had a vision that, in all honesty, would most likely strike fear into some dyed-in-the-wool farmers. I'm probably being a little over-dramatic here, but the duo wanted to allow the land to regenerate, working with nature to bring back species into the landscape in a sustainable way that would be economically sound and demonstrate that there is another way of making a living off the land. It was a simple and common-sense approach, yet many farmers would probably disagree with it. When two 'southerners' come to buy a northern farm in a time of well-publicised land grabs by companies in Wales for example, there are bound to be doubts about their motives. But the previous owner listened to their plans and accepted that they had a different approach. He was intrigued and continues to visit the farm and discuss progress.

Catherine and Tim's vision for Kingsdale Head was to support nature recovery as part of sustainable land management and farming, have an appreciation of and respect for the land and local communities, to collaborate with others and share experiences, and to appreciate that listening to a diverse set of views and opinions is fundamental to success.

They appointed Jamie McEwan as Conservation and Farm Manager in late 2020; he and his wife Amy have a wealth of knowledge in the farming and environmental sectors, and the trust is there for them to get on with the job. A management plan was developed with help from a small group of advisors including the Woodland Trust, Yorkshire Peat Partnership, Yorkshire Dales National Park, and many others, drawing on the best local expertise.

There's no doubt Kingsdale Head is a unique and diverse site. It has around 1,100 acres of peatland including blanket bog, as well as wet heathland, fen, and wet grassland. It's gills and streams are a welcoming habitat for brown trout and freshwater invertebrates, whilst there's a further 247 acres of acid and calcareous grassland and developing meadows. Then, there's 32 acres of mature woodland and a further 40 acres of tree planting that had already taken place.

It's a big, complex site with many challenges, so it begs the question: why did two people from Hampshire decide to buy a windswept upland farm in the Yorkshire Dales when they could have done this a little closer to home?

Tim says,

We wanted to do something rather than just talk about it or to give some money to charity. The work, more locally at Knepp, was an inspiration but we wanted to try a similar approach in an upland environment. There aren't any upland farm sites in Hampshire. We looked at Wales, Scotland, and Northumbria, and then Kingsdale Head came up. It was the perfect site for us and matched what we wanted to do. It was one big block of land at the top of a valley, had a great watershed, and the previous farmer – Michael Faraday – had it in a Higher Level Stewardship since 2011. For us, it felt like there was already a movement here, less sheep and a less intensive way of farming.

We completed the sale in April 2020, just at the start of the COVID-19 lockdown, so Michael and his wife Stephanie couldn't move. They stayed on, looking after the farm, until Jamie and Amy arrived in November. In hindsight, we were glad of the extra time as it gave us the chance to get to know Michael and Stephanie, and the workings of the farm. It also gave us time to find Jamie and Amy, and we're delighted to be working with them.

It's important to say that this farm needs to be sustainable, and financially so. Farming practices may change because of various agricultural payment schemes and systems, but if people can see this farm works, and can sustain a living, then it could be something they can do.

Catherine adds:

There are many reasons why we chose this land. It isn't high agricultural output land; it has always been marginal, and the three fields around the house are the only bits of improved grassland. We aren't taking good agricultural land out of production, we are utilising a lower production system and producing other outputs that aren't purely agricultural. We are looking at how we can bring wildlife back and sequester carbon because those benefit everyone.

Even though the team have only been at Kingsdale Head for a short time, the changes are abundant. Jamie broke up some of the field drains early in his tenure and wetland biodiversity has increased in those areas. The farm is restoring and re-wetting its peat – some 5,000 dams have been installed through the Yorkshire Peat Partnership – and, although the previously planted woodland schemes had used stakes and plastic tree guards, additional planting has all been done without.

This wasn't some blanket approach though. Lots of surveys have been completed to establish baselines for flora, fauna, fish, amphibians, and birds. They've engaged with universities too and above all they want people to see what is happening. Plenty of groups have popped by to look at progress and get involved with some of the projects.

Jamie says a key phrase that sticks with me: 'We are genuine about doing positive things.' He continues:

We want to make a difference and see what the land does. We know we must create different revenue streams, but it all fits in with our ethos. We have a small herd of cattle here for conservation grazing and some will go for beef, creating a real farm to fork story. We've also had Tamworth pigs – they certainly had an impact on an area of the improved grassland and a field next to one of the woodlands. We are now watching to see how this will contribute to natural regeneration.

What's impressive about Kingsdale Head is the team's willingness to listen to others and try different things. They've been open and honest from the outset; something rather uplifting. Catherine and Tim are also heavily involved too, visiting as often as they can from their Hampshire home and actively learning about what's happening on the land. They have connected with Neil Heseltine, farmer and chairman of the national park, and have visited other landowners and projects taking regenerative approaches to land management. Catherine says:

This is something that is a big part of our lives. It's important. Part of the enjoyment is learning about the farm and seeing over time how it can develop. It was key for us that we had Jamie and Amy in post quickly, so this could be a place where people lived and worked. It was important there was someone on-site, engaged in it day after day, rather than us directing from afar.

I know Tim feels this way too but it's quite sad that we won't get to see it at its peak. You are looking at a fifty-to-100-year time horizon before it really changes, when you think of lifecycles. We have to balance our impatience and settle into the timelines that we need to engage with. We know it will take time to see major changes, but even in one summer, we are already seeing much more heather and bilberry coming through. It's exciting.

Upland farming will certainly change over the coming years as we transition from subsidies to 'public money for public goods'. Kingsdale Head was reducing its headage long before it was sold, affecting grazing pressures, and now those sheep have been removed. That brings two key results: a better chance for biodiversity to increase across the fell, but a reduced income for what was a traditional hill farm.

Whether upland farms can survive without subsidy is debatable; sheep prices were trending well above average in 2021/22, but it does mean enterprises have to diversify now more than ever. At Kingsdale Head, like many farms, they have a holiday let which is very popular. They are also keen on accessing corporate partners who have a genuine interest in supporting peat restoration, biodiversity, and the landscape. They are also well primed to take advantage of the new Environmental Land Management schemes. The key focus remains the same: transforming the landscape into a thriving and diverse eco-system.

When you think about the complexities of farming and a rapidly changing world, you could say there's a heap of pressure on the farm managers' shoulders. It doesn't

show, though; Jamie is the most laid back and welcoming man I have ever met, confident in his abilities, with a belief in trying different things.

'It's amazing to think about the species we could have here,' he says. 'Adders should be on a site like this as well as red squirrels. Historically, there were beavers here too! When I am high up in the fell, I often think what it might look like when I'm no longer here. It's hard to plan that far ahead and predict what might happen. We are introducing processes to bring things back, but it will go the way it wants to I'd expect.'

Tim adds: 'We all have a similar picture of what we'd like to see, and sometimes different ideas of getting there. I think we will have a mosaic of habitats. The peat will be rewetted and stable, and there will be more flora and fauna. The nearby Wild Ingleborough project is exciting, and I'd like to think in fifty years what we have done here will be linked to that. We will have amazing wildlife corridors.'

Catherine said: 'A mixture of texture and colour, small shrubs, and trees, particularly along the beck is what I'd expect to see. We might get some alpine plants on the scree slopes and that means more botanical interest. There are so many micro-ecosystems here and it's exciting to think what we might achieve.'

The team at Kingsdale Head are determined to make a nature-led upland farm work. They want it to be financially sustainable but are aware they may need to adapt to changing environmental schemes and, of course, the climate. The fact Tim and Catherine are in it for the long haul suggests it has an exciting future and could be a beacon for increasing biodiversity and carbon capture across the Dales.

A wooded plantation opposite Kingsdale Head Farm.

Above left:
Conservation grazing:
a small herd patrols
the land.

Above right: Along
the beck in tranquil
Kingsdale.

Right: Kingsdale Head
Farm.

Kirkby Stephen

One of the northernmost villages in the national park, Kirkby Stephen joined the Yorkshire Dales in 2016 when it was extended to include Westmorland. It has a range of great shops and pubs and is the hub of walks into the upper Eden Valley and is part of the Coast-to-Coast Walk.

In the tenth century much of the area was settled by Vikings – kirk-by being Norse for church. By 1090, the village was known as Cherkaby Stephen, although it is not clear where Stephen originates. Ann Sandell on the village's website writes:

There are several theories. If we delve into ancient records we find that after the Norman Conquest there was a revival of the monasteries. The income from Kirkby

Stephen went to the newly founded Benedictine Abbey, St. Mary's of York whose first Abbot was Stephen de Whitby. The second explanation is that the name is a corruption of 'on the Eden' giving us Kirk-by on the Eden. The third is that it is an Anglo-Saxon word 'stefan' meaning moor. This last theory is said to be supported by the locally pronounced Stevven instead of Stephen.

The church of St Stephen is well worth a visit. Built of soft red sandstone, it's known as the 'Cathedral of the Dales' because of its 'size and elegance'. It isn't known when the first church was built, but at its west end are stones that date back to between 1,000 and 1,400 years ago. Ann says: 'The earliest stone church dates from about 1170, part of which can still be seen with the most worn stones. This was replaced in about 1220 and there has been continuous improvements through the centuries.'

The real highlight of the building is the 'Loki stone', a bound, bearded devil who may represent the Norse god Loki. Information from the church says that: 'According to Nordic myth, Loki was fettered and tormented by his fellow-gods in punishment for the killing of Baldur the Beautiful. The stone dates from around 900–1000 and once also formed part of a cross shaft, though we can only speculate about the other images that once stood above and below it.'

Inside, you cannot fail to be mesmerised by the high arches and beautiful tiled floor. It is Grade II listed.

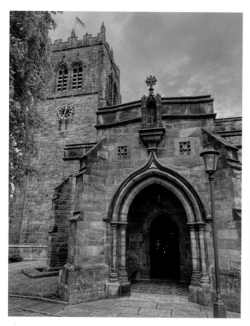 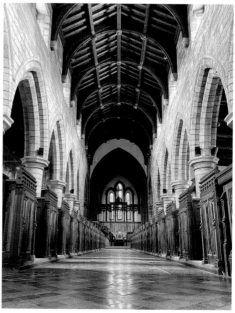

Above left: The church of St Stephen. (Johnny Hartnell)

Above right: The church's stunning interior. (Johnny Hartnell)

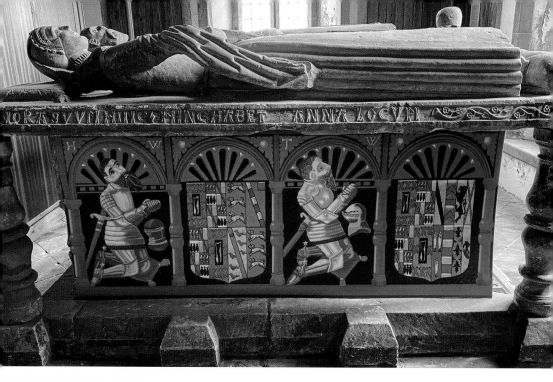

Some of the fascinating artifacts and monuments on display in the church. (Johnny Hartnell)

Lady's-slipper Orchid

This plant, *Cypripedium calceolus,* was thought to have been extinct in England at the time of the First World War, yet several people insisted it could be found in the Yorkshire Dales, hidden from view to preserve its unique status.

The Joint Nature Conservation Committee (JNCC) describes it as having 'large solitary flowers with maroon-brown petals and a pouched yellow lip; found in open woodlands on calcareous soils, usually on north-facing slopes'. It is 'widely distributed through northern, central, eastern and south-east Europe, westwards to Norway and the south-west Alps and eastwards across Asia to Sakhalin Island on the Pacific coast'.

In the UK it has always been local, formerly occurring in limestone districts of Derbyshire, Yorkshire, County Durham, and Cumbria, but is now a native plant in Craven. You can view it at two other sites as well – near the Field Centre at Malham Tarn and Kilnsey Park near Grassington. Both examples are protected for obvious reasons, with the former being propagated by the National Trust.

Jamie Roberts looks after the orchid at Kilnsey Park, with people being able to view it on the nature reserve between mid-May and June. It is open from 9.30 a.m. and 5 p.m. seven days a week, with a small charge for admission.

Kilnsey had a considerable number of the orchid according to Curtis (1782), but as an attractive and bold plant it was sold in Skipton and across other markets in northern England. Jamie passed me a draft chapter of a guide for the *New Naturalist* series that stated, 'The Lady's Slipper continued to be found at other localities in the Ingleborough district, but was "rarely met with"' in 1838, and by 1888 was said to be 'very rare'. It is thought that it was accidentally rediscovered by two walkers in 1930, although that is disputed as 'Jack Smith' says he found it two years earlier. Sightings were made in other locations too but were kept secret.

Anonymous notings of the orchid allowed people to organise to protect it. 'The likelihood of a single flower being pollinated naturally was very small even if the plant was self-fertile' the draft chapter says with the 'best solution to pollinate the plant artificially when it flowered'. This happened by hand from 1971 by the Cypripedium committee and under laboratory conditions at the Royal Botanic Gardens Kew from around 1983. Here, they 'pioneer(ed) methods of propagating and conserving

European orchids including methods of propagating *Cypripedium* plants from Dales seed'.

The fact that we can still see lady's-slipper orchid in the Dales is down to the hard work of those who didn't want to see our natural heritage disappear. At Kilnsey the fruits of these endeavours can be seen – the work of generations so the public can view this stunning plant.

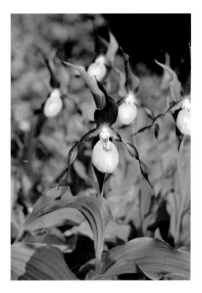

Right and below: You can see why the lady's-slipper orchid was much sought after – now it is protected. (Jamie Roberts)

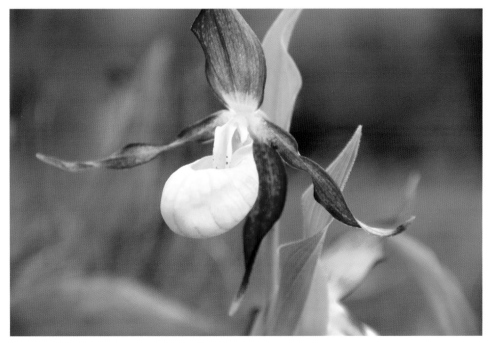

Limestone Pavement

The Dales is famous for its limestone pavement, but you'd be surprised to know that finding it in 'good quality' across the country is rare and declining. It is considered a priority habitat by the JNCC and in the Dales it is protected by Limestone Pavement Orders and continues to be on the UK and local list of priority habitats for biodiversity.

This geological feature forms when the carboniferous limestone is dissolved by water over millions of years to form clints. The crevices and fissures between them, which can reach depths of 6 metres, are known as grykes. This habitat can attract a wide range of unusual species including, according to the JNCC: 'Woodland and woodland edge species, such as hart's-tongue and dog's mercury. On the clint surfaces or the upper walls of the grykes there are plants of rocky habitats, such as wall-rue and maidenhair spleenwort. The grykes provide a shady, humid environment favouring woodland plants.'

Clearly, grazing pressure will decipher how diverse these habitats are. At Scar Close, near Ingleborough, herbivores have been kept away since the 1970s, meaning woodland has appeared alongside other rare species. Even when there are sheep and other grazers near the pavement, grykes can still house herbs and ferns.

It is thought there is around 2,600 hectares of limestone pavement in Britain, with nearly half being found in the Dales. Great Asby in Westmorland is a fine example, whilst Southerscales near Ingleborough and Malham are well-recognised sites too. As well as the species recognised by the JNCC, these pavements contain holly fern, limestone fern, rigid buckler-fern and as well as bloody crane's bill, common rock-rose and lily of the valley. Wood anemone can exist too, as well as primrose – likely to be relics from earlier woodland cover.

The limestone pavement in Craven is the single remaining native site for lady's-slipper orchid. The JNCC say it was reduced to a single plant on this site, but 'careful habitat management, together with hand-pollination of the few flowers that appear, and more recently re-establishment of plants from ex-situ propagation, has led to a steady increase in the size of the colony'.

These pavements are best seen from late April to August for flowering species, with ferns lasting well into the autumn.

Limestone pavement under the shadow of Ingleborough... (Mark Corner)

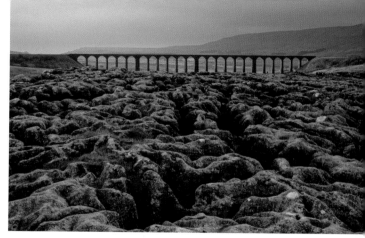

...at Ribblehead... (Mark Corner)

...and holding onto life at Twisleton. (Mark Corner)

Littondale

Littondale is a small dale near Upper Wharfedale, guided by the River Skirfare, which meanders along the valley floor until it dips below ground at Litton. At the head of the dale is Pen-y-Ghent and it is also home to the Scoska Wood National Nature Reserve.

At Arncliffe is the Falcon, the original Woolpack in long-running soap *Emmerdale* until filming relocated to Esholt in 1976. The ITV programme shot their outside scenes around the village, no doubt because it reflected village life in the Dales perfectly. The way it serves its beer is the real treat, though: Timothy Taylor's Boltmaker served in the time-honoured traditional way from a jug. It is decanted from the cask in the back room and then poured from that jug, when ordered, into your glass. It gives the ale a chance to breathe and certainly brings out its flavour at room temperature.

Arncliffe was first mentioned in the Domesday Book, its name being of Old English origin, meaning 'eagles' cliff'. The dale has been settled for thousands of years, with archaeologists discovering several prehistoric and later settlements along its length. During the medieval era it was owned by monastic houses.

Littondale, near Arncliffe.
(Mark Corner)

Lune Valley

At more than 105 kilometres, the River Lune is one of the longest rivers in the north-west of England and a key facet of the landscape. It has helped shape the fells, moors and crags, valleys and pastures, floodplains and estuary, and alongside its tributaries drain an area of 1,223 square kilometres towards its confluence with the Irish Sea west of Lancaster.

It rises at Ravenstonedale Common on the northern slopes of the Howgills in Cumbria and flows west to Tebay. It then turns southwards, through the Lune Gorge and along the western slopes of the Howgills before it heads southwards to the market town of Kirkby Lonsdale. There, it crosses under the magnificent Devil's Bridge, leaving the Dales on its way to Lancaster. The bridge itself is very popular with tourists and motorcyclists, as well as wild swimmers and canoeists. It's also said to be the place of a deal between an old woman and the Devil. He appeared to the lady, promising to build a bridge over the river in exchange for the first soul that crossed over it. She agreed but when it was finished, threw food knowing her dog would cross the bridge and outwit the Devil. Poor dog, I say.

Devil's Bridge. (Johnny
Hartnell)

M

Malham Cove

Imposing from all angles, Malham Cove is the Dales' true jewel in the crown, attracting thousands of visitors every year. And it's easy to see why: an amphitheatre of limestone stretching 260 feet into the ether and around 985 feet wide.

Originally, a waterfall higher than the Niagara Falls would have flowed over Malham Cove as a glacier that covered much of the region retreated. As it melted, it carved out the dry valley behind it – the Watlowes – with the meltwater finding alternative ways to filter through the fissures instead of creating that stunning waterfall.

The water that flows out of Malham Tarn takes this old meltwater course and goes underground at Water Sinks, and the theory used to be that it was the water that emerges at the bottom of Malham Cove. Dye testing suggested this water emerges south of Malham at Aire Head, while the Cove's water is from a smelt mill some 2 miles away ... although it's not that simple.

Cave diver John Cordingley had, until recently, been exploring the underwater passage at the Cove and a 'flood rising' to the right. He suggested in *Secret Yorkshire Dales* that 'if you walk around the Malham area in very wet conditions, there's only one very big stream sinking – the Tarn outflow – and one big stream resurging from the base of Malham Cove'. He said:

> Water tracing over the years, with more sophisticated techniques, has shown that this simple model (the smelt mill source) only really applies in dry conditions. As flows increase during very wet weather the tarn water overspills its low flow sinks and travels progressively further down the valley, utilising progressively older and older sinks. Eventually, it reaches the normally dry waterfall where the two dry valleys converge in the Watlowes and sinks in a large pool at the base of the fall. It was never known to go any further than that, in living memory, until December 2015, when Storms Desmond and Eva caused even this sink below the 'dry' waterfall to overflow, allowing the stream to continue all the way to and over the Cove.
>
> Most of the normally dry sinks in the Watlowes valley do drain to the Cove and as the flow gets further and further down the valley towards it an increasing

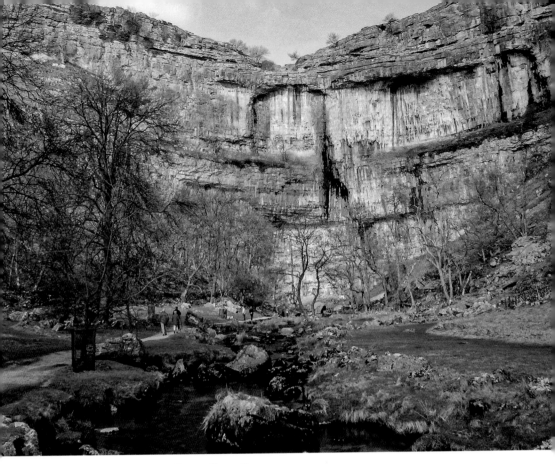

Imposing limestone wall at Malham Cove.

proportion of the water flows to the Cove resurgence. However, some of the water draining to the Cove comes from further away to the north west, from the Grizedale's area and even as far away as Gorbeck. The old theory isn't really right, it's clear these underground flows cross and/or mix, depending on weather conditions.

Malham Sedge

If you're looking for a unique species at a unique location then *Agrypnetes crassicornis*, or the Malham Sedge, ticks the boxes. In Britain this caddisfly is only found only at Malham Tarn. It was discovered here by Paul Holmes in the 1950s, but had not been recorded for some time, and was thought to be extinct, until Emma Ross found one in around 2006. Observations are being undertaken by Sharon and Peter Flint, who are dedicated to not only studying the caddis in this stunning environment but also fighting for its protection. Above all, they are passionate about a little insect that many wouldn't think twice about if they were lucky to see one.

Peter is an entomologist who followed in the footsteps of his father, an amateur in the same field. He met Sharon at Lancaster University when he was working as an entomologist in the Department of Biological Sciences. Sharon says:

I went to Lancaster University in 1993 to read ecology. When I finished, I did a PhD on river flies, and really got into caddis but there was only one identification key available, and I hated it! It was difficult because it looked at wing venation. That's where Peter came in; he helped me decipher that whilst the key had some great illustrations for differing genitalia. I was using a range of trapping methods for caddis but when they landed on the glue you couldn't see the wings, only the genitalia. I have to say I got very obsessed with caddis genitalia.

Following my PhD and the Foot and Mouth crisis in 2001 we moved back to Yorkshire from Lancashire and were located around half an hour from Malham Tarn. We were trying to decide what to do with ourselves, so we chatted to Robin Sutton, who was deputy manager of the Field Studies centre here. After checking our background, he asked us to run a course – and we did from around 2008.

Three years later, Robin told us that Ian Wallace had been looking for a rare sedge, but it didn't really matter to me as I wasn't really interested in rarities. Ian has written everything you need to know about caddis in the country and had been filmed by the BBC on the Tarn at night looking for the sedge. I said to Robin, because I liked a challenge, that I would find it … and we did in 2013.

Sharon says that caddis love *Chara*, and the tarn is full of it, particularly in the summer. This is really important for an *Agrypnetes* because when it comes to pupate it stuffs one of the ends of its case with this stonewort. Her hunch was that it they would be able to find it just offshore.

We went out in a boat with a grapnel, and as soon as we found the *Chara*, we threw it over and brought it back in. When we did that there were masses of caddis on it. We found lots of the common *Limnephilus politus* but knew that the *Agrypnetes* had a spiral case. We found one – a juvenile – but this was in September and that was deemed a rarity. It was thought its flight period was in late June and early July but that seemed a bit specific and a very short timeline. This was thanks to work by Paul Holmes, Alan Brindle, Marjorie Andrews, and Ian. As the years have gone on, we found that its flight period is actually much longer.

This discovery led to the duo finding the caddis in its other life stages. Sharon even had one land on her leg, meaning an up-close and personal look at how it moved. Peter added:

They really do move fast. They don't make a dispersal flight but why would you want to fly if there's nowhere else to go? They emerge as adults, somewhere out on the

tarn, because they've pupated amongst the *Chara*, and when they're ready to emerge as adults they swim up to the surface. When they reach the surface they run to the shore – rather like a speedskater on the water surface.

We've seen that at night. It comes out at the same time as other caddis, but you can tell it's an *Agrypnetes* when you've got your torch on because it is skating like hell! It seems not to like the light, but we know we have to confirm that. We'd also like to film it making the journey.

Finding out how many of this rare species is at the tarn is a big job. There are records from the 1950s and 1960s that suggests there were 'lots' in June, but Sharon and Peter can't concur that with their more modern-day observations. They've seen them all the way through July to the end of August, and in September as one off, but it's clear that summer is the prime sighting time. Therefore, the question is, is it possible to say if it is declining or expanding? 'We have a lot more work to do on that,' Sharon added, continuing:

Peter has been able to note the 'shuck', or cast skin, from the *Agrypnetes crassicornis* that come to the shore and that means we do not have to disturb the animal anymore. We have done some intensive work over some years – and from our other research it's becoming increasingly clear this is the only site in the UK that has it. We have been looking for it in marl (alkaline) lakes on the Isle of Lismore but haven't had any success yet.

It's going to take the amateurs to find and monitor these special insects and the people who have the time and enthusiasm to do it. Is this thing on its way out? Is it becoming extinct here or is it doing quite well? We don't know because no one's ever done quantitative studies. That said, the important thing is that it's here, at Malham Tarn. It's not, at the moment, a protected species, even though it is only here. I'm assured it will be scheduled as protected, but what does that actually mean? Not a lot, I guess. We know that Peter's information about being able to identify the shuck is critical in the development of a possible monitoring method for this caddis. Now we need to develop that.

The crux of protecting a species like this is, of course, what support is available. Peter and Sharon do this all off their own backs, using knowledge and practice gained over decades. They also need the public to play its part. When the *Agrypnetes* comes to the shore it will hide under rocks; yet sadly these are often moved in summer when people come and visit the tarn. In a true sense, this is habitat destruction, but people won't see that. Sharon said:

The serious point about this is that the animal lays its eggs in a jelly loop. These will literally be just offshore in a small amount of water. The eggs of the animal are attached to these rocks and that could be damaged if they are moved. The shore is a

delicate habitat and it's our study area too. If it is moved, then it could damage the insect and our work in monitoring it.

The tarn is a special place and discoveries of insects like this make protecting it even more important. Should the ecology of the lake change – nutrient enrichment through pollution could affect the *Chara* for instance – it may change the habitat for this caddis and everything else that relies on it to live. That would be a shame. Until then, and here's hoping never, enthusiasts like Sharon and Peter are vital if we are to protect our important wildlife.

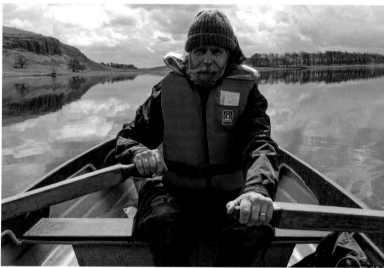

Above left: Agrypnetes crassicornis. (Sharon Flint)

Above right: Peter surveying for caddis at Malham Tarn. (Sharon Flint)

Right: Sharon looking for *Agrypnetes* in *Chara*. (Sharon Flint)

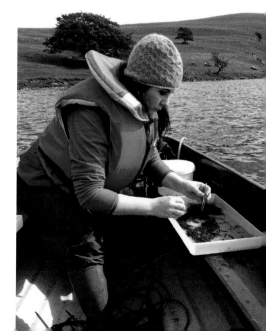

Mallerstang

Originally part of the Westmorland Dales, the 'dale' of Mallerstang is around 6 miles to the south of Kirkby Stephen. It is the starting point of the River Eden, which flows from Black Fell Moss into the valley at Aisgill and it's thought that Dick Turpin once leapt over this gorge on his horse to escape arrest ... and with that we note that area has plenty of legend about it!

Mallerstang features its edge on one side and Wild Boar Fell on the other – the place that purportedly saw the last wolf in the country killed. Then there's Pendragon Castle, which legend says was founded by Uther Pendragon, the father of King Arthur and the site of a Roman fort built as a stopping-off point between their sites at Bainbridge and Brough. Archaeological evidence suggests a different tale, as the present castle dates from the late twelfth century – before it became part of the Clifford family estate. The castle was reputedly set alight by the Scots in 1341, before being rebuilt in the 1360s and beset by fire once again in 1541. Lady Anne Clifford restored it in 1660 to 1662, adding stables and a bakehouse to return it to its former glory.

Near Lammerside Castle, itself built in the twelfth century and strengthened in the fourteenth to protect against Scots raiders, are the Giants Graves, which were thought to be Bronze Age burial grounds. They are, in fact, 'pillow mounds': stone mounds that were covered in earth and used as artificial rabbit warrens. Rabbits were imported from Europe and used for meat and clothing.

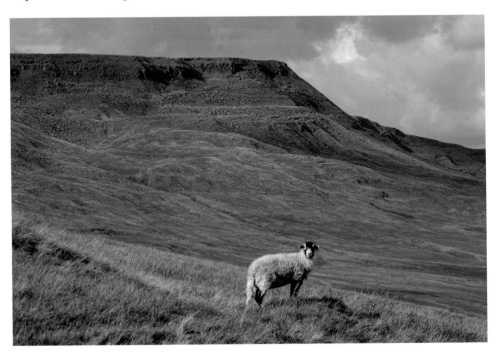

Wild Boar Fell in Mallerstang. (Mark Corner)

Northern Brown Argus

The northern brown argus is a small butterfly with a silvery appearance when it flies low over flowery grasslands. It is a priority species that has its southern limit in the Yorkshire Dales. Butterfly Conservation says:

> In Scotland, most individuals are of the race artaxerxes and have a characteristic white spot in the middle of the forewing. In northern England, this spot is generally dark brown or black. Similar to Brown Argus but differentiated by orange spots. The butterfly occurs mainly as small, scattered colonies and has declined in northern England.

The group say its distribution has declined by 27 per cent. This butterfly – around 29 millimetres in wingspan – likes well-drained, lightly grazed or ungrazed unimproved grasslands. 'They prefer sheltered habitats, frequently with scrub and patches of bare ground such as sand dunes, quarries, coastal valleys and steep slopes.'

Protecting the habitat for this species is vital and, as a result, the butterfly is on several priority lists across the country.

Northern brown argus. (Shutterstock / Erik Karits)

O

Orton

Orton is a bustling village in the Westmorland Dales. It features a thirteenth-century church, many traditional cottages, and the mouth-watering Kennedys Fine Chocolates shop. This is a small family chocolate-making business that has been producing luxury chocolates since 1991. The village also has a burgeoning farmers' market too.

Orton Fells and Scar are a mile north from the village and the latter features a limestone pavement that is seldom visited. Walks from the village lead up to the Scar and beyond that is Castle Folds, a small fort and wall constructed to hold cattle during Scottish raids, whilst Orton Hall was built in 1662.

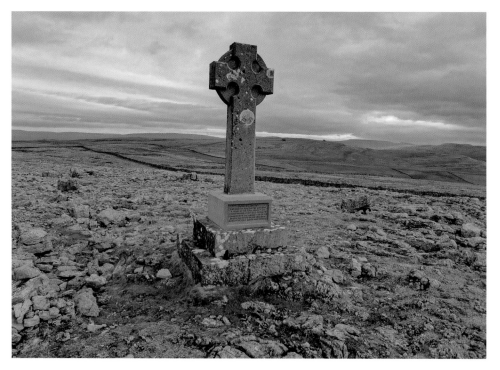

Orton Cross. (Mark Corner)

P

Pen-y-Ghent

Pen-y-Ghent means 'Hill on the Border' in Cumbrian or 'Head of the Winds' in Welsh. Distinctively shaped and rising 2,273 feet, it is traditionally the first stop on the 26-mile Yorkshire Three Peaks Walk out of Horton-in-Ribblesdale. Its peak is predominately millstone grit, which sits on carboniferous limestone. Then comes sandstone, shale of the Yoredale bed, Great Scar limestone and slate.

If you approach from the west then you can see the 'pinnacles' or rakes, which were formed by a thunderstorm in July 1881 according to local sources. Soil was washed down to a significant depth, exposing these fine features, and as a result they are popular with climbers.

Pen-y-Ghent is a real rite of passage for those who walk in the Dales. Many people will climb it from Horton-in-Ribblesdale, but there's two other routes well worth considering. One is from Helwith, which means you miss the crowds in Horton, while my favourite is to walk up the lane at the back of the Crown Pub towards Sell Gill Holes

 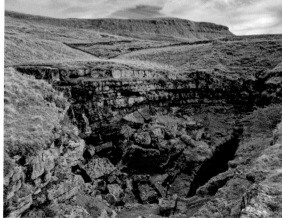

Above left: The walk up to Pen-y-Ghent. (Fiona Busfield)

Above right: Hunt Pot on the way up, or down, Pen-y-Ghent. (Fiona Busfield)

and then turning right onto the Whitber Path. From there, you can head left to the superb Hull Pot chasm before returning and climbing up Pen-y-Ghent via Hunt Pot.

Purple Saxifrage

The alpine plant purple saxifrage likes damp, vertical rocky ground, usually where carboniferous limestone and shale meet, making the summits of Pen-y-Ghent and Ingleborough ideal habitats. The best time to see it flowering is from April to June, although it can poke out from February as snow begins to melt.

This plant is special because it is the highest-flowering plant in the European Alps, according to Nature's Work, and 'the most northerly flowering plant in the world ... found across the northern hemisphere from Canada to Japan'. It likes calcareous rocks and calcium and base rich soil conditions – both found at the tops of two of the Three Peaks. Nature's Work continues:

> Its scientific name, *Saxifraga oppositifolia* derives from the Latin *saxum* meaning 'rock' and *frangere* 'to break'. The many plants which share the name Saxifrage aren't 'rock breakers' but they live amongst rocks and screes which are shattered and broken by severe cold temperatures releasing nutrients for the plants to take up through their roots ... It forms one of our many relict arctic-alpine plants found at the very edge of their world distributions. It is a superb coloniser of land uncovered by retreating glaciers.

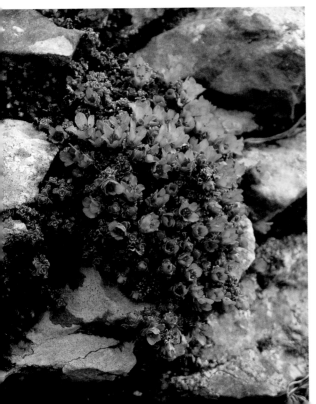

Purple saxifrage. (Jane Robinson)

Q

Quaking Pot

We've outlined the longest cave system in the Dales, so it seems only fair to talk about the longest and toughest trips cavers can undertake.

Now, pinning such monikers to caves brings with it a certain bout of author's licence. What's tough for someone, could be easy for another. Whilst a trip could take hours for a caver who likes to take their time, some can do it in a lot less. So, bear with me.

I'm told the hardest caving experience in the Dales is Quaking Pot, located on Ingleborough once you've passed through Crina Bottom. The guidebooks certainly do indicate it is a bit frisky. There are ten descents ranging from 2 to 24 metres, and a 17-metre fault climb before the final 5-metre pitch just to get to the end of the system at Gormenghast. And there's the crux, an awkward 7-metre crawl-traverse that comes after 'Coitus Corner'. I think we'll leave that explanation to the imagination. The trip in total will take around ten to twelve hours.

Finding cavers who have done the trip was fairly easy, but those who want to talk about it less so! There was a well-publicised rescue in 1994 that was filmed and the use of choice language throughout indicates how tough the trip is. One caver, Liz Lawton, told me:

> I did Quaking Pot maybe three times many years ago. The first time I did it was with someone who had been before, so I had lots of advice on body position, which I think was the key to it being hard but ok as a trip. I think if you were a team that didn't have anyone who had done it before there was a fair chance it would take a couple of attempts. I remember it being strenuous but ok, as long as you thought a bit about where your body was. The crux on the way out was the bit that preyed on my mind. It never felt nice, and I was always relieved to be on the right side of it!

The longest trip is Penyghent Pot, which could take up to seventeen hours to complete a return trip to Interdiction and Too Long Gone Sump in the Living Dead Extensions. Even those named passages frighten me, and the route to the first pitch is a fifteen-minute, hands-and-knees crawl in water along the canal. The ninth pitch is named Myers Leap after Jack Myers, who wrote the seminal caving book *Underground*

Adventure, fell down the pitch. John Cordingley described the tumble for the *North Craven Heritage Trust Journal.* He wrote:

> Other notable involvement in discoveries included Notts Pott (Leck Fell) in 1946, Ease Gill Caverns and Lancaster Hole (Casterton Fell) over several years from 1946 and Penyghent Pot, from 1949 onwards. The latter is a very fine pothole on the east side of Ribblesdale, in which Jack had the dubious pleasure of having a feature named after him. He had attempted to glue together a two-piece wartime-surplus lifeboat suit, with only partial success. The resulting 'waterproof' caving suit became increasingly cumbersome as it started to fill up with the icy liquid. It caused him to slip off a vertical drop into a pool (which broke his fall, at least to some extent). No serious harm was done and, in a demonstration of typical cavers' sense of humour, this shaft has been known ever since as 'Myers' Leap'.

R

Raydale

Raydale is located the south of Wensleydale. It features Semerwater, the second largest lake in the Dales, which feeds into the shortest river in England, the Bain, at just 2.5 miles in length.

Semerwater is thought to be the site of a once prosperous city in the Dales. Legend has it that an old man came to the city in search of food and drink. He knocked on each door, being rebuked every time, before he found a welcoming hovel where a poor couple pitied him and took him in. After enjoying the couple's hospitality, the old man turned to face the town and said, 'Semerwater rise! Semerwater sink! And swallow the town, all save this house, where they gave me meat and drink.' Immediately, the waters of the lake rose, enveloping the city and its citizens, but saving the couple who took him in.

The view down Raydale. (Mark Corner)

Fed by water from Cradle and the beck around Raydale, its name derives from the Old English meaning lake, mere and water. It was formed, or dammed, when moraine was deposited as a glacier retreated. Water did find a way out of the drift eventually, cutting the course of the River Bain before it finds its way to the River Ure at Bainbridge. Originally, the lake would have stretched up Raydale, some 2 miles.

At the lake are three large granite stones known as the Carlow Stone and Mermaid Stones, which were deposited by the ice flows. The Carlow Stone landed, apparently, after a giant on Addlebrough threw stones at the Devil on neighbouring Crag Hill. The stone is one that was dropped by the giant, although it is also said that it was thrown there.

Redmire Falls

These falls are off the beaten track, just a few miles downstream of Aysgarth falls, along the River Ure. They are a multi-drop fall, a haven for bird life and, above all, a lot quieter than their more well-known cousins up the river.

There are several ways to get to the falls, but they are all on foot as parking is limited. Both sides of the River Ure offer good walking and you can take in a trip to Berry's Farm at Swinithwaite, which is around half a mile away. Either walk downstream from Aysgarth or upstream from West Witton. The falls are a popular spot for wild swimmers.

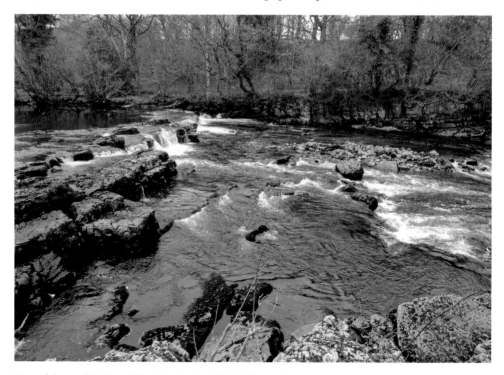

One of the multi-drop falls at Redmire. (Mark Corner)

Ribblehead Viaduct

One of the most mystical places in the Yorkshire Dales is Ribblehead Viaduct, its twenty-four arches supporting the weight of the historic Settle–Carlisle Railway, and a heritage that has been much recorded.

The line's roots stretch back to the 1860s when the East and West Coast Main Lines linked England and Scotland. The Midland Railway had to negotiate terms with their operating rivals if they wanted to move freight or people beyond their boundaries. That was never as successful as it should have been, so the firm looked at building a route from Settle to Carlisle to avoid the use of other companies. After agreeing a proposed line, the company lobbied Parliament for permission – with success. No sooner was that granted than relations with rival rail companies improved for the better. Midland asked for the decision to be reversed but that was rejected.

With no going back, construction began in 1869 and was completed in seven years with around 6,000 men working across the 73-mile route. The line was opened to passengers on 1 May 1876, with freight having been carried for the first time roughly a year previously. In 1968, the service became entirely diesel operated, but all local stations – apart from Settle and Appleby – closed in 1970. Eleven years later, recommendations were made to close the route to passengers, mainly because of the sheer cost of weatherproofing Ribblehead Viaduct. A project manager was then appointed by British Rail to close the line, but instead he encouraged passengers to use it more and local stations reopened in 1986. Three years later, the government backed his approach.

The landscape around Ribblehead is filled with the legacy of its construction. When building began at Ribblehead in 1869, materials for the major architectural projects of the viaduct and Blea Moor Tunnel were manufactured locally and brought on to the site via small steam locomotives on a small tramway. The stone would be transferred from Ingleton by horse. The viaduct's foundations were sunk some 7 metres down and laid by steam cranes. Before you take the obvious path down to Ribblehead you can see the faint outline of the Batty Green construction camp. Here there were offices and shops, a small town of wooden shacks. A little further down the road, to the right, was a smallpox hospital.

On the main path to the viaduct, you'll approach a fork in the route and the tramway on the right. Materials would have been housed where the Station Inn is now. At this junction there was a locomotive maintenance shed and an inspection pit so mechanics could get underneath. The Porter & Co. of Carlisle brickworks are just a little further along the tramway, and at the height of construction around 20,000 bricks a day were being produced there. Brick workers were housed in a shanty town on the moor called Sebastopol – named after the Crimean War siege of 1855 – with Inkerman, Jericho, Jerusalem, and Belgravia nearby. There were 150 huts between Batty Moss and Dent Head and, according to the 1871 census, they had more than 1,000 men, women and children living in them, many of whom died during the construction due to accidents and smallpox.

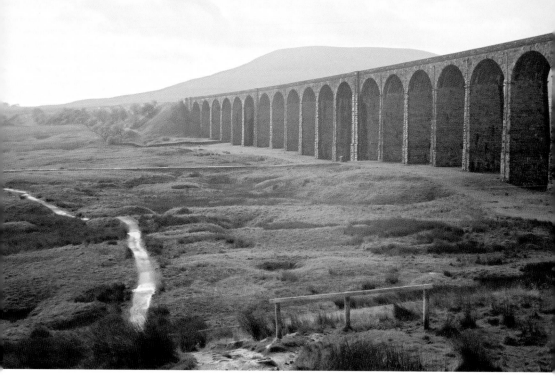

The impressive Ribblehead Viaduct.

Ribblesdale

Ribblesdale is one of the larger dales in the national park, taking in not just the viaduct but the sweeping pastures through Selside to Settle. Outside the boundary it also encompasses Long Preston and Hellifield.

The Ribble Way runs through the dale, beginning at the River Ribble's source at Gavel Gap, high on the moor above Newby Head, and ending some 70 miles later at Longton which is 4 miles to the south-west of Preston. It can be done from south to north as well – the correct route, but I've added some bias into this! In fact, Ribblesdale is a hive of long-distance walk possibilities with the Pennine Way, Pennine Bridleway, Pennine Journey, and Dales High Way all crossing the dale.

The River Ribble – around 75 miles in length – is a fantastic place to see salmon leaping up waterfalls in autumn as they return to their spawning grounds.

Robinsons' Pot

The entrance to this cave is unusual as it is directly under the kitchen window at Darnbrook farm, a National Trust tenancy around 3 miles from Arncliffe.

Cavers with a permit – this isn't somewhere you can visit and enter without one – will simply lift the lid (pictured), ladder the entrance, and descend some 7 metres

into the passages below. That pitch lands in a small chamber before continuing into the 1862 Chamber, rediscovered after the cave was reopened in 1975. What follows is a short trip that has classic and well-decorated streamway and some interesting off passages.

Deborah Hall lives at Darnbook with her partner James and says that whilst she wouldn't go and have a look at the cave herself, she does like watching people ladder up and head down.

> We moved here in 1995 and a lot of people have visited the cave since then. Students, caving clubs, Cave Rescue ... all sorts have visited us. As long as we can carry on doing what we are doing then it doesn't matter to us that there's a cave entrance under the window. We even leave a hose pipe in the garden so people can wash themselves off. When I'm in the kitchen you don't hear water underneath. There's a lot of rock between the cave and myself so I don't really think about it.

Deborah says the original house at Darnbrook was built in 1664, but was here long before then as it was mentioned in the Domesday Book. It was one of the monk's houses likely connected to Fountains Abbey.

> The cave was 'discovered' in 1975 when the people who lived here were taking flagged floors out. One of them dropped a bar and it just went away. I'm guessing the entrance was probably a drain with a grate and no one knew it was there until the metal bar fell through it. When they started to look at the passages, there was graffiti from 1862 in there – so the new owners rediscovered it. It's fascinating that it is under our feet here.

Ian Brindle wrote about the rediscovery in the Craven Pothole Club's *Journal 5* in 1975. His article, 'Ramifications beneath Darnbrook Farm', says renovation work saw blue slate flags removed from the kitchen door, revealing a low-built arch into the house wall. This piqued interest and further excavations revealed a 'twenty-two foot shaft which was almost straddled by the outer wall of the building. The water flow in the kitchen had led the occupiers to think that a hidden well was backing up and it was the ensuing search for this well which led them to the concealed entrance'.

David Hodgson was one of the explorers called to look at the new entrance alongside Harry Long. When they investigated, they saw it was 'partly walled up on one side and had shot holes clearly visible', meaning it had been explored before. When the pair reached a little further into the opening passages of the system, they found the names of previous visitors 'in bold Victorian letters. The date of one visit, writ larger than the rest, gave the friendly chamber its name – 1862 Cavern'. Further examination of the pioneer explorers revealed they were all local people, mostly farmers.

Subsequent explorations have now revealed more than 2 kilometres of passage.

Above: A grid or a cave entrance?

Below: It's open!

Above: The phreatic streamway. (Bill Nix)

Right: Mud formations in Robinsons' Pot. (Bill Nix)

Below: Gours in the streamway. (Bill Nix)

Scaleber Force

Drivers on the route out of Settle to Malham wouldn't know this wonderful waterfall was here unless they'd pre-planned a visit or took a punt after seeing a few cars parked up. It's not signposted and only a small Woodland Trust 'Scaleber Wood' marks the spot … kind of. Trust your instincts and descend the tricky path.

Here, Stockdale Beck falls 40 feet into an amphitheatre of woodland, thanks to the action of water. It has eroded the limestone, which is on the South Craven Fault, into a deep gorge. Drink it in, there's nothing to do but watch the waterfall tumble over the rocks in a beautiful setting.

Stockdale Beck making its way down a stunning scene.

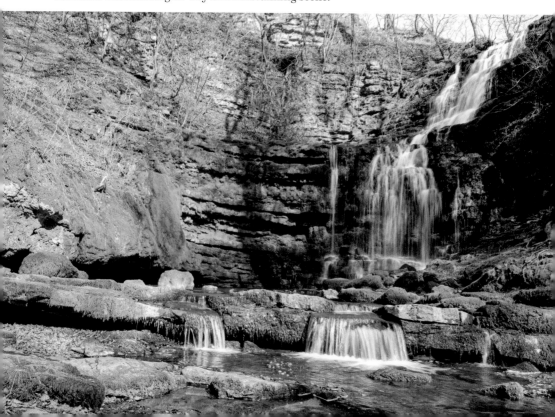

Showcaves

There are three showcaves in the Dales: Ingleborough Cave, near Clapham; White Scar Cave, near Ingleton; and Stump Cross Caverns on the road to Pateley Bridge from Grassington.

Historically, there were more across the park – Skirwith at Ingleton; Holme Hill, near Ribblehead; and the famous Yordas Cave in Kingsdale, for example – but the first two aren't a great introduction for amateur cavers.

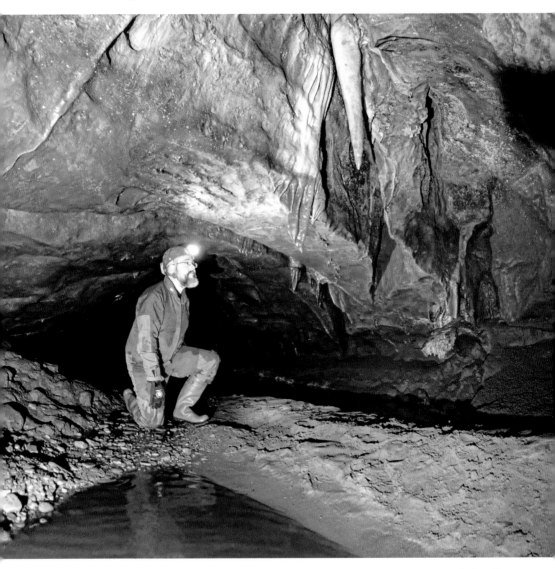

Beyond Ingleborough showcave: the author is at a decorated cross joint in the roof of Cellar Gallery, at the inner end of The Styx pool. (John Cordingley)

Ingleborough Cave

One of the finest showcaves in the country and part of the huge Gaping Gill System, although there isn't a dry link between the two as Fell Beck makes its way to the showcave via submerged passages. It was opened in 1837 when local landowner James Farrer realised that large passages had to exist behind calcite barriers a short way into the cave, following a severe flood. He set local workmen to break these dams and subsequently discovered the extensive passages that lay beyond.

At the end of the tourist path, the passage continues to the left, passing through galleries and arches until it narrows and eventually connects with Gaping Gill. The link between the two was made in 1983 by the Bradford Pothole Club and Cave Diving Group, although the connecting link at Radagast's Revenge has now collapsed.

White Scar Cave

Discovered in 1923 when Cambridge student Christopher Long was on a holiday in the Dales and noticed a slight gap in the ground. Putting his head in, he heard the roar of water, crawled over rocks and through pools until he came to the foot of a waterfall – all with just candles stuck into his hat to illuminate his way. Several other trips into the system saw Long swimming across lakes, squeezing past a massive boulder the size of a double-decker bus (now known as Big Bertha) before he could go no further. Spurred on by his adventure, he had plans to open it as a showcave, but sadly died of an anaesthetic overdose. Lieutenant Colonel Geoffrey Smith took up Long's work, blasting and installing lights and flooring up to the second waterfall. It opened on 10 April 1925.

In the 1970s, the Happy Wanderers caving club managed to navigate the boulder and squeeze up into a massive cavern called the Battlefield Cavern. It was Hilda Guthrie who had the honour of entering the boulder-strewn cavern for the first time and witnessing its staggering stalactites and other features. Now, a tunnel connects the showcave to this cavern.

Stump Cross Caverns

The caves lie underneath Greenhow Hill, right on the border between the national park and Nidderdale. Discovered in 1860 by lead miners Mark and William Newbould, they were opened for the public three years later for the princely entrance fee of 1s. They were sold in 1926, with Septimus Wray and his grandson George Gill taking over years later. They installed electric lighting, and the caves remained in the family until 2003. There is around a mile of passage open to the public at present, although the caves themselves are probably more than 5 miles in length, with new discoveries continuously being found.

St Leonard's Church

This beautiful old church is sited on an old Roman route across Chapel-le-Dale and has been a place of rest and reflection for hundreds of years.

It's not exactly known when a place of worship was founded here, but the land was owned by the monks of Furness Abbey in the fourteenth and fifteenth centuries. Back then, the dale was known as Weyesdale and it is assumed that a small chapel would have existed: a chapel of ease, spiritually attached to Low Bentham, a place that would have been too far for locals to travel. In 1595, it was recorded as the 'Chapel of Wyersdaile' in a Chester diocesan document. Some twenty-three years later it was the 'Chapel of Witfalls' and sixty years after that 'Chapel 'ith Dale', although the latter is more likely to be a colloquialism. From there it was commonly known as Ingleton Fells Chapel.

St Leonard is, ironically, the patron saint of prisoners. It's suggested that a local historian found an old will referring to the church by that name, but subsequent research said that was connected to a chapel in Ingleton. Either way the moniker stuck, despite not being officially dedicated. It was renovated in 1869 – the same time Chapel-le-Dale became a parish in its own right – and that was handy in a sad way as the number of fatalities from the railway construction camps at Blea Moor and Ribblehead was about to increase significantly. In 1870, a smallpox epidemic took the souls of many navvies and their families and in the end more than 200 were buried here – so much so that the land around St Leonard's had to be expanded.

Revd Ebenezer Smith worked closely with the Midland Railway's missionary worker, James Tiplady, to care for the families on the railways and to bury those who perished in the east side of the churchyard – most in unmarked graves. The burial records for this time make startling and sober reading.

It is fitting that there is a plaque in the church to commemorate the men who died in the construction of the railway, and in 2000 a simple stone monument was raised to cherish the memory of those wives and children who passed away.

St Leonard's Church, Chapel-le-Dale.

Stalling Busk

Stalling Busk is a tiny and secluded settlement to the south of Semerwater. It has two churches: St Matthew's, which was commissioned by Revd Frederick Squibb in 1906, and the ruins of an older site, which was rebuilt in 1722.

A place of worship was first built here on common land between the village and the lake in 1603, but it fell into ruin during the English Civil War (1642–51). In 1722, villagers bought the land and rebuilt the church, with the first curate being Anthony Clapham. It lasted there for 183 years until Revd Squibb was named vicar of Askrigg and Stalling Busk. He was wanted to move worship from the old church into a new building in village.

A year later, permission was granted to construct a new building, with various fundraising efforts taking place. In 1908, building work began and the church was dedicated on 20 October 1909. The church's history states: 'It had taken six months to build with T Gerard Davidson as architect and John Moore of Hawes as builder. The new church was built in a traditional cruciform but does not face east because of the lie of the land ... The total cost was £815:12:5.'

In 1913, the Thwaite monument, font, pulpit, and other items were moved to the new church, and it was decreed that the old church was in a bad state of repair. 'The removal for use or sale of roof timbers, windows and casing to help to defray the expenses of building the new church was permitted.'

It has since been restored but links with the old church remain. On St Matthew's day in 1969 a 'solemn act of confession took place in the old church and was followed by a procession to the new church. The old bell rang out over Semerwater from the old church tower courtesy of modern technology'.

The 'new' church is a welcoming place but what is surprising is how well the 'old' site remains. It can still be seen on a short walk from the village, looking over the serene Semerwater.

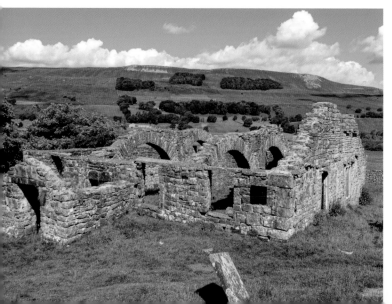

Remains of the old church at Stalling Busk. (Mark Corner)

Swaledale

One of the most beautiful dales in the national park – a real working landscape that has a touch of industry and agriculture wherever you look. Gunnerside features hallmarks of extensive mining, Muker displays farming practices of the past with its meadows, and there are historical links with Viking settlers with names such as Keld, Angram and Thwaite.

There's also the corpse road from Keld; for many hundreds of years, the only consecrated ground to bury your dead in Swaledale was at Grinton. This meant carrying your deceased in a wicker coffin for several kilometres over some very harsh terrain. These routes became known as corpse roads or corpse ways. From Keld, the route goes over Kisdon Hill before it descends to Muker and on to the Ivelet Bridge, an attractive single-span bridge built in the seventeenth century. Here, a coffin stone lies – a large, flat stone set in the corner. It is one of a number on the route that would allow pallbearers the chance to rest the coffin so they could take some ease. At Ivelet is also Ramps Holme Bridge and Ivelet Wood, an ancient wood pasture. They would then have continued onwards to Low Row where corpses would be left in the 'dead house' above The Punch Bowl inn whilst mourners rested. In 1580, ground was consecrated at Muker, so the journey didn't need to be made anymore.

Swaledale is a special place; the River Swale at its heart, flanked by drystone walls and field barns, and the bustling village of Reeth at the far east. At the west of the dale, Tan Hill Inn is the highest pub in England.

Naturally, much of this landscape has focused on farming. The Swaledale sheep, as well as being the park's logo, are a hardy breed and one that most would associate with the Yorkshire Dales. They have distinctive curled horns and a thick fleece.

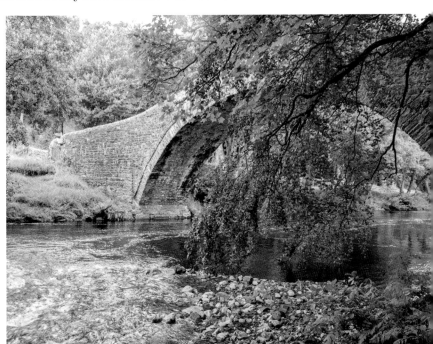

Ivelet Bridge.

Thorns

The medieval settlement of Thorns is around 2 kilometres from Ribblehead, near Gearstones. It was first recorded as place of residence in 1189–90 when it was bought by Furness Abbey as part of a vast estate covering this area of the Dales. It ran from Chapel-le-Dale to the top of Whernside, on to Newby Head, and then over to Low Birkwith and Selside. It also went right up to the Lancashire border at Bowland and covered most of Ingleborough.

The monks established a sophisticated set-up with four large estates at Southerscales, Winterscales, Selseth (now Selside) and Birkwith and a hierarchy of settlements

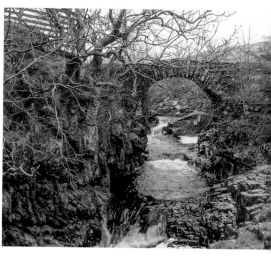

Above: The packhorse bridge at Thorns.

Left: A historic hamlet in a serene setting.

known as lodges. Newby was its headquarters and Colt Park, as the name suggests, was a stud farm. Whilst Thorns wasn't a lodge, it wasn't at the bottom of this tiered system. At the time of the Dissolution of the Monasteries, there were six tenements, five of which have been uncovered by archaeologist and historian Dr David Johnson and several volunteers. By 1891 there was only one uninhabited dwelling. Thorns passed through various dukedoms since the Dissolution until the whole manor was bought by the Farrer family in 1810. They stayed connected to the area until 1953, when they had to sell up because of death duties.

At the site now are visible remains of three houses, and three more in the earthwork alongside crumbling barns and a communal out office. It's a quiet and serene place, which if you're planning to visit, should be viewed from the paths only.

Trollius Europaeus

The globeflower may not be endemic to the Dales but is an interesting upland plant. It can be found in wet meadows or damp woodlands.

It gets its name from the spherical 'globe-shaped' yellow flowers, which are made of ten yellow sepals – leaves that encase the developing flower – rather than petals. It is a member of the buttercup family but has suffered decline because of increased drainage and intensive agriculture.

As more than 97 per cent of wildflower meadows have been lost since the 1930s, with flower-rich grassland now only covering a mere 1 per cent of the UK's land area, according to government statistics, several organisations are working hard to restore these precious habitats. Globeflower is a crucial part of the upland meadow mix, and meadow enhancement usually involves bringing species such as wood crane's bill and great burnet from donor meadows to boost the sward.

Interestingly, the globeflower has an associated group of flies, *Chiastocheta*, that it relies on for pollination. Other species struggle to get through the sepals. However, even though they pollinate the flower, the females lay their eggs in the plant and the larvae eat the seeds. Effectively they help and hinder the plant reproducing.

Globeflower. (Tanya St Pierre)

U

Ure

The River Ure is approximately 119 kilometres (74 miles) long from its source at Ure Head on Abbotside Common before it flows down Wensleydale, through Hawes and beyond, eventually being joined by the River Swale at Myton-on-Swale. Here, at Cuddy Shaw Reach, it changes its name to the Ouse.

It is the principal river of Wensleydale, which is the only major dale now named after a village rather than its river. *The Cambridge Dictionary of English Place-Names* (2010) states that the name probably means 'the strong or swift river', whilst that moniker has been noted as Earp in 1025 and Jor in 1140 and then Yore. The dale used to be called Yoredale.

The Ure – the principal river in Wensleydale. (Mark Corner)

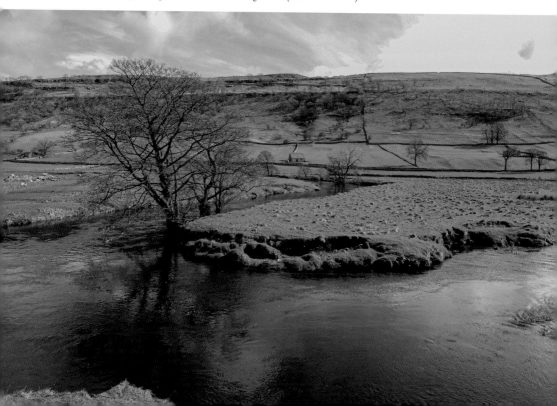

V

Valley of Desolation

One of the walks from Bolton Abbey follows 'the Valley of Desolation', which links the River Wharfe corridor to Barden Fell. It got its rather depressing name from when it was devastated by a great storm in 1826, when strong winds, torrential rain and flash floods uprooted many of the original oaks. Some of these remain on the walk through Barden Moor, but this place once supported rowan, birch, and hawthorn, whilst hazel and alder would have been seen along the wetter parts of the valley floor.

Some planting has taken place since the turn of the millennium and already these are transforming into thriving young woodlands. These plantations were designed to illustrate the natural succession of the species developed along the valley of Posforth Gill and on the fells since the end of the last ice age, although actual ancient woodland can never truly be replaced.

Elsewhere on the Bolton Abbey estate, set in 30,000 acres of stunning countryside, is Bolton Priory. The land here was granted by Augustine order in 1154. Scottish raiders damaged the site in the early fourteenth century, but it continued as a parish church

Veteran oak tree in the Valley of Desolation.

even after the Dissolution of the Monasteries in 1539. The other buildings had their lead roofing removed, causing the stonework to weaken and collapse. The existing church is impressive too; you enter via the unfinished West Tower, which could have looked a lot different if the Dissolution hadn't occurred. The plan was to match the splendour of the nearby Furness and Fountains abbeys, which would have seen the Gothic west façade beyond the tower demolished. The incomplete tower was finished by Canon Slaughter in 1984, and featured a pine roof.

Victoria Cave

In 1837, Michael Horner was walking his dogs above Settle when one caught the scent of a fox and chased it into a nearby hole. When it failed to return from its hiding place, he removed debris from the tiny entrance, crawled inside and rather luckily found coins in sediment from the Romano-British period. We presume he found his dog too. A year later, his boss Joseph Jackson, a glazier in Settle, began removing stones from body-sized hole Michael had inadvertently excavated and named the subsequent new cave after the Queen, who had just been coronated.

What they eventually discovered was one of the most important caves, historically, in the world. In the topsoil, alongside those plundered coins a year previous, were other artefacts such as brooches. Pottery and decorated stones from the Iron Age followed and then a harpoon point from around 12,000 years ago – the first evidence of people in the Dales. Items from Neolithic man and animals were also found too, including deer, horse, a reindeer antler, and the complete skulls of two grizzly bears.

Next, narrow-nosed rhino, hippo, hyena, and elephant bones were uncovered, the hyena bones suggesting the site was used more than 130,000 years ago as their shelter and a place to hunt, when the climate was much warmer than it is today.

Visitors can enter Victoria Cave, which is near Langcliffe (SD 8372 6506), to gain wonder from those early explorations, but it is protected site and certain sections are understandably blocked from access.

Looking out of Victoria Cave. (Mark Corner)

W

Wensley Church

The Grade I listed Church of Holy Trinity was built during the reign of Henry III on eighth-century Saxon foundations. It sits on the bank of the River Ure in the east of Wensleydale. The south chancel survives from that period, but changes were made to the rest of the building in the fourteenth and fifteenth centuries. The nave, aisles and north porch were restored in the former, with the addition of the vestry and the raising of the aisle roofs with armorial shields added to the buttresses in the latter. A tower was added in 1719. The Scrope family of Bolton Castle supported the church from the thirteenth century and have their own seventeenth-century private pew.

It's a fascinating and historical place, with medieval wall paintings, monuments and a fifteenth-century reliquary, which the Churches Conservation Trust says is 'a container for either the bones of a saint, objects associated with them or other holy items.' It adds: 'This reliquary is believed to come from the White Cannon's Abbey of St Agatha at Easby which was established in the Anglo-Saxon period and dissolved by Henry VIII in the 1530s.'

The oak chancel pews date from 1527 and were carved by the 'Ripon Carvers', whose work appears in Ripon Cathedral. The poppy-head bench ends are decorated

Wensley church and ox-eye daisies. (Shutterstock/ Andrew Fletcher)

with real and heraldic animal figures. In the sanctuary are stone seats intended for the officiating clergy. They date from the late twelfth to thirteenth century and have dog-tooth mouldings. And there's a brass that commemorates church rector Sir Simon de Wensley, who died in 1394. The full-length brass effigy of the Flemish school is 'considered to be the finest example of its kind in an English parish church', according to the Churches Conservation Trust. The church is open for visitors daily.

Wensleydale

We've spoken about this tranquil dale several times, but beyond the cheese at Wensleydale Creamery, the River Ure and waterfalls, are places to be enjoyed.

The remains of a Roman fort at Bainbridge – Virosidum – is at the end of a road that would have run to the fort of Verteris at Brough. It was in use for 400 years until AD 410. Groundwork still survives on the glacial mound it occupied; it was around 91 by 111 metres and would have been 1 hectare in size. It had several ditches as defence positions – two on the north, one at the south and five on the west. It also held a headquarters, granary, and barracks. Yorkshire Dales National Park historians say at the east was an annexe for more troops and was defended by a stone wall, which has been identified as the *bracchium caementicium* (stone-built outwork), built when Alfenus Senecio was governor of the province of Britain.

In Aysgarth is an Edwardian rock garden, which was commissioned by Frank Sayer-Graham, and near the west side of the dale is the remains of Jervaulx Abbey, which was plundered during the Dissolution of the Monasteries in the sixteenth century.

Bolton Castle is also a fascinating place; one of the best-preserved examples of a castle in the British Isles. It was built from 1379 after Richard le Scrope, Lord Chancellor of England to Richard II, was given licence to create a fortress. It took twenty years

Bolton Castle is one of the best-preserved castles in the country.

to complete and was seen not only as a site of defensive power but was extravagant too, befitting the status of its owner. There were en suite toilets and a complicated chimney system. For nearly 150 years it survived intact until, in 1536, it was burned down by King Henry VIII as a punishment for Sir John Scrope's reluctant support of the Pilgrimage of Grace. Additionally, Mary, Queen of Scots was imprisoned there in 1658, and you can visit her bedchamber on the third floor. More than a hundred years later, it was besieged by Parliamentarian forces during the Civil War, and the family left the castle for Bolton Hall in 1675.

Westmorland Dales

On 1 August 2016, the national park grew by an extra 161 square miles (417 square kilometres) taking in new areas in Cumbria and Lancashire. In the north, towards Tebay, the extension brought the Westmorland Dales inside the new boundary, encompassing 28 per cent of the park. It has seventy-nine Scheduled Monuments, nineteen Sites of Special Scientific Interest and two National Nature Reserves. From the limestone pavements of Great Asby Scar to the Howgills and Mallerstang, it's a shame it was hidden away for so long.

Wharfedale

Shaped by the River Wharfe, Wharfedale has a U-shaped valley that is more wooded than others in the park.

The first 15 miles are known as Langtrothdale and feature Yockenthwaite, home to some of the best meadows in the national park, and Hubberholme, where you can see a historic church and 'candle pub' at the George Inn. This Grade II inn, built in 1630, was originally a vicarage before being a hostelry in 1754. When the vicar was home, he would put a lit candle in the window to signal to his parishioners that they could come and see him. That custom continued when it became a pub, and the current landlords still have a lit candle on the bar. Quite simply, when the candle is burning, the pub is open. Prolific writer and playwright J. B. Priestley frequented the village and called it the 'pleasantest place in the world'. In the snug is a corner dedicated to him and he is buried in the church across the river.

There's also an annual land-letting ceremony that the pub hosts for the village. The Hubberholme Parliament meets every year to auction 16 acres (6.5 hectares) of pasture that was bequeathed to the parish back in the early nineteenth century. Taking place on the first Monday in January, a service is held at the village church to celebrate the forthcoming land-letting and then the vicar comes across to the pub with his wardens. Tradition says he must ask the landlord if he has prepared the candle and once lit, the auction begins. Anyone can bid for the land and when the candle goes out whoever has

the highest bid wins and hands the money over to the church. They gain the rights to graze the land whilst the church shares out the money to the poor in the parish.

A few miles away is Buckden, whilst Kettlewell is a little village popular with cyclists and great for pubs. Further down the dale is the impressive Kilnsey Crag and then the bustling hub of Grassington and its fantastic Dickensian Festival in Winter and waterfalls at Linton. Nearby are Burnsall, Bolton Abbey and Appletreewick with its historic Craven Arms.

Sheep clipping the pasture in Wharfedale. (Mark Corner)

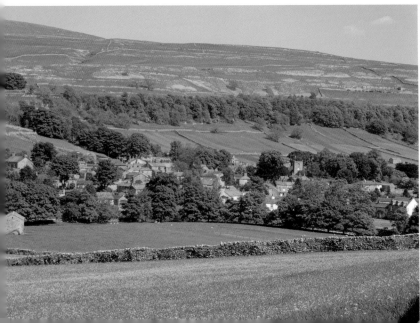

Kettlewell. (Mark Corner)

Whernside

Whernside is an oddity! At 2,415 feet, it's often overlooked compared to its Ingleborough and Pen-y-Ghent siblings. But the ridge, which opens out to views stretching right down Ribblesdale, is one of the finest wanders in this part of the national park.

But why is it an oddity? Walk along this ridge and, if you stay to the left of the wall, approaching from Blea Moor, you are in Yorkshire. Touch the trig point, which is about 2 metres from that wall, and you are in Cumbria. Yet, it's known as the 'Roof of Yorkshire'.

The traditional route to the summit takes you past Ribblehead Viaduct and Blea Moor signal box before following the path to the left before Blea Moor Tunnel. Passing Force Gill Waterfall on the left, you climb up further before turning left, over the stile, to head towards the ridge. Alternatively, you can climb via Dent taking in Whernside's peaceful tarns or the Dales High Way on the way.

On descent, you can turn right and take in Bruntscar and, if you have some miles in your legs, Ellerbeck and the St Leonard's Church in Chapel-le-Dale. Most people will head towards the Old Hill Inn to continue the Three Peaks walk or turn left to return to Ribblehead.

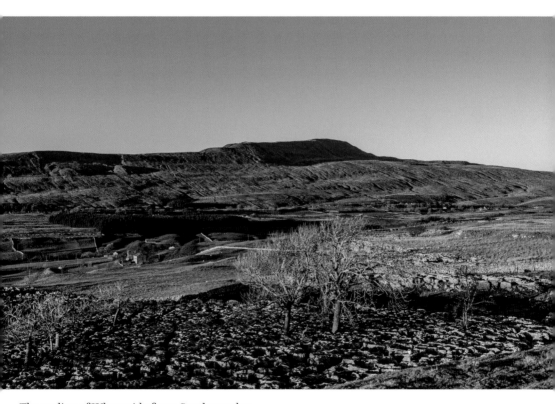

The outline of Whernside from Southerscales.

Woodlands

Less than 2 per cent of the Yorkshire Dales National Park is currently covered by broadleaf woodland, around one-fifth of which is 'Ancient Semi-Natural Woodland'. It is often said that there is more tree cover in London than in the Dales. There are several reasons why this is the case but many organisations are working hard to reverse the trend. The Dales has seen a planting boom over recent years as landowners take advantage of new funding streams to create important new habitats.

The beginnings of that change in landscape have been overseen by the National Park Authority and Geoff Garrett, who until recently led the woodlands team. 'There's a certain thing about Dales' woodlands that is unique,' he says. 'There are thin limestone ash woodlands, and others which define a dale. If you look at Garsdale, a lot of the woodlands run from top to bottom, into the bottom of the hill, but if you look at somewhere like Wharfedale, a lot of the woodlands run along the sides and on discrete slopes. We will build on these distinctions as more trees are planted.'

Woodlands in the Dales have changed over the years through use, an increase in agriculture and other pressures. In Swaledale, for instance, lead mining saw trees being removed for coking to produce lime from limestone. A lot of this practice involved coppicing, where species like hazel would be cut to the base to preserve the tree, and the subsequent regrowth harvested decades later. Geoff points out that if you compared a map from the 1850s to the current day, you wouldn't see much change in woodlands in terms of size as the damage and loss occurred much earlier.

> When I came up here, I helped to write the first of our woodland strategies. We had pressure to create more woodlands because the existing ones were very vulnerable. We wanted to connect these woodlands to others and create bigger ones. My work was to get the strategy together and push the idea to landowners. One of the hardest parts of the role was to talk to people about the benefit they would have by creating a woodland. There are obviously some challenges with this across the country, especially within farming, but one thing we would help with is the creation of small woodlands in field corners and on unproductive land. We would take farmers through the process and make it as easy as possible. It was a partnership; we took the time to sit down to get to know the family, what they were doing and what they would like.

Yorkshire Dales National Park Authority has always been one of the leading administrations in terms of woodland creation, but a lot of that is due to the fact it has the least cover. Now the choice facing farmers, especially in the uplands, is stark: do they try and give land over to trees and other environmental benefits, or do they re-intensify? It's not an easy choice to make when the average farmer in the Dales is past retirement age. Geoff said:

There's one farmer I knew who farmed 200 sheep. He's faced with the fact that he's not going to get any kind of basic payment for sheep anymore. So, he said 'well, my choice is literally do I plant this entire field up with trees and try and get as much as I can for that or do I intensify and get new sheep'. The latter is going to have a detrimental effect on the Dales, isn't it? The National Park Authority is working very hard to try and make something that works for farmers.

Geoff has seen a great deal of change over his career and particularly the increasing use of plastic tree shelters on schemes.

There was a time when there wasn't plastic, and we managed to plant and create woodlands without it. We need to look back and use those techniques if we want to put a lot less plastic into the environment, and how they used to do it or find an alternative. We spent a long time trying to find a perfect guard for the national park environment and the uplands. We eventually concluded that a mesh tube with film around it was by far the best. It would give the tree an initial start, then the film would break down introducing it to the environment so it could grow in its climate. The guard would then keep the browsers off. They worked well but now we have a problem with the legacy of these guards in the landscape. There is a growing debate about how to remove the guards from the landscape and what could be used as a sustainable alternative to the plastic guards that would be effective.

I think people totally underestimate the actual input, time, labour, and TLC that is required to get a tree from being tiny to being big enough to survive. They need to be around 6 inches in diameter in order to not be impacted by grazers and even then, sheep will graze them in the right conditions. When you're looking at natural regeneration you need a seed source and sadly there's not many trees in the Dales for that. It can happen if you leave it to natural succession and you'd get the woodland that you were expecting in about 150 years' time. By planting woodland, you are cutting 150 years out of that development. With natural regeneration you probably get the best woodland for the natural environment, but you won't get anything like a woodland which is created to produce timber or something that's designed for education. I can see both sides of the argument of whether we should plant or regenerate. The fact is, we need woodlands for differing purposes and timescales.

The original plan in the Dales was to plant 2,000 hectares of woodland in twenty-five years. This was achieved, and then a strategy was devised to reach a further 6,000 hectares in ten years. Geoff says it's likely the park will get close to that ambitious target, but it's important these woods are looked after, whether they use tree shelters, fencing or other methods to control browsers such as deer and rabbits. That means the regulatory system around grants will need to ensure woodlands are checked after ten years. This will encourage landowners to maintain their sites long after the excitement and fanfare of them being planted is over.

Despite the increase in planting, one thing that will never be replaced, in the short term at least, is the ash, which is being lost to ash dieback (*Hymenoscyphus fraxineus*). Ash woodland is iconic in the national park, as are the field trees, which have been in corners and boundaries for generations. Geoff said:

> We know we're going to lose a lot of ash one way or another, but there is expectation that somewhere along the line, we will get an ash that's resistant. That may take several generations and will depend on the viral load of the disease. At some point there may be small spore loading, as most of the ash will be gone, that will allow trees to grow – or we'll get to a situation where the forest sector has found a resilient ash tree. The woodlands they were dominant in will evolve; we will get mixed woodlands and the ash, in time, will return to them. Effectively, in the park, we are planting ash woodlands without the ash. We've got all the components of ash woodland without that dominant species so that ash can become a part of the woodland at some time in the future.

Above left: Beech corridor in Grass Wood, Grassington.

Above right: Evidence of coppicing in Grass Wood.

The ash field trees are a lot less vulnerable because the spores can't travel as far as they can in a dense woodland. I think those individual field trees should be with us for a lot longer, probably for the length of their natural life. The issue for me is even if there wasn't any ash dieback, those trees are dying naturally and not being replaced. How they got there in the first place is a conversation in itself but they aren't being replaced and that's a shame.

What's important is to realise that woodland is lost over a long period of time and as a result people don't really notice this type of landscape change. Two of my favourite woods are Grass Wood in Grassington and Oxenber and Wharfe Woods near Austwick. They remain because people look after them. As a community, on both a local and national level, we need to continue to recognise the importance of what we have and actively work with all those interested, to protect it and make it more robust and less vulnerable. Like a lot of the important habitats in the National Park that are being protected, action is needed otherwise we could easily lose them.

X Marks the Spot!

The adage 'if you don't look, you won't find', is none more apt for the Westmorland Dales and Great Asby Scar in particular. The landscape partnership for the region has enabled archaeologists to really tap into what was happening there by providing funding for detailed surveys to build on previous work.

And they've understandably revealed an incredible amount of archaeological material since 2016. Before surveys were undertaken there were just fifty-nine known sites in one section of the limestone plateau. Now there are 1,218, thanks to the work of Northern Archaeology Associates (NAA) and Lunesdale Archaeology Society (LAS). A recent report read:

> Evidence of human activity on the Scar dates back to the Bronze Age with many burial mounds present across the Scar. Later, in the Iron Age and Romano-British period, settlements on the north flanks of the scar show extensive signs of habitation. In subsequent centuries, settlement appears to have continued with fields cleared, pens built and boundaries constructed, for both livestock and cultivation. In medieval times much of this became common land split between the parishes of Great Asby, Crosby Ravensworth and Orton. It would have primarily been used as pastureland for the livestock of the nearby settlements. In the late medieval period until the nineteenth century, the land on the Scar was slowly enclosed. This process caused a significant change in the landscape with the erection of countless dry stone walls to separate land parcels. Accompanying this movement was a move toward greater agricultural efficiency and lime kilns were built locally to create quicklime which was used to improve the soil. In the late eighteenth and mid-nineteenth centuries, copper was extracted from the north slopes of the Scar. Turf cutting was also an important industry with examples found on the Scar.

In total, they found 207 industrial sites, 21 settlements, 249 agricultural sites such as enclosures, 315 cairns and waymarkers, 12 burial cairns, 96 tracks, 232 places stones, 17 ditches, 80 pieces of wall furniture and 28 sites of ordnance from the Second World

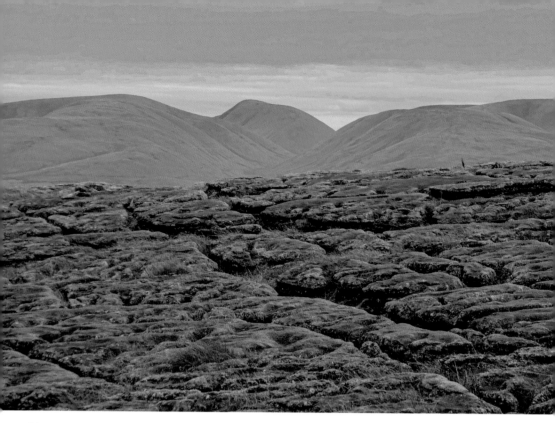

Limestone pavement at Great Asby. (Mark Corner)

War. There are 109 'structures of unknown use' too, leading to more investigation, and various surveys are taking place on Little Asby.

These archaeologists are literally just scratching the surface as there are bound to be more important finds to come.

Yeti

When you're researching an area you love a great deal, one you've walked over and been part of for years, you'd think there's nothing left about it that would surprise you.

Well, in late 2022, I was sent a short video clip of British cryptids – animals that some people believe may exist in the wild but are not recognised by science – and I was taken aback. Apparently, one of these has been apparitions was sighted in the country, moreover in the Yorkshire Moors, and it's called the Yorkshire Yeti.

The video entitled *British Cryptids: Yorkshire Yeti* was released in 1974 but only seems to have been 'shown at schools or languished in public libraries', according to the poster. It starts with the line 'between 1956 and 1961, over twenty sheep worrying incidents were said to have been due to the actions of the Yorkshire Yeti', and then discusses mutilated sheep carcasses that haunt shepherds to this day.

In 1949, a dozen dead sheep were killed by an animal of some kind that wasn't a dog. In the autumn of the same year, reports of similar deaths appeared in the Yorkshire Moors – again, discounted by farmers as a canine incident. Stories abounded that the Night Shepherd's evil twin, the Black Shepherd, was carrying out the killings – the former being the good man who brought sheep back to safe pasture after dark. Then, at Troller's Gill, near Appletreewick, the Barguest, a huge black dog with large teeth and claws could have been the cause.

Some six years later there were even more attacks on the moors, with an eyewitness saying footprints in the snow could be the abominable snowman.

The atmospheric, and of the time, video ponders some questions and is well worth seeking out. Plus, British Cryptids were also able to acquire *Hereford Twiggywitch*, *Stag Men*, *Souter Sea Wolf*, and *Cave Children of Coniston* too … so log on to YouTube and enjoy your evening!

Yorkshire Sandwort

The English or Yorkshire sandwort is a sub-species of the Arctic sandwort that grows on the limestone plateau between Horton-in-Ribblesdale and nowhere else!

Its leaves are around 4.5–5 millimetres in length, with its white flowers around 11–13 millimetres in diameter when they are on display between June and September.

Arenaria norvegica subp. angelica is endemic to this small area. It grows amongst limestone fragments and in hollows with a thin covering of soil on level or slightly inclined limestone exposures. It was discovered at Ribblehead by Lister Rotheray on 12 July 1889. In 2000, K. J. Walker noted that:

> Over 70 per cent of the entire population of around 2,000–3,000 plants occurs within two adjacent pastures where numbers are apparently stable. However, it has declined on tracks and bridleways where it was first recorded over 100 years ago. Although colonies within pastures appear to have fared better, their frequent small size (less than fifty plants) makes populations susceptible to drought and disturbance. The current rarity owes more to climate change (contraction of habitat) and aspects of its autecology (limited seed production and dispersal) rather than human activities. However, grazing and recreational disturbance still threaten some populations.

Above left: The Yorkshire sandwort – found in the Dales and nowhere else. (Peter and Ruth Kerr)

Above right: A delicate thing! (Peter and Ruth Kerr)

Right: Its habitat niche is in limestone pavements. (Peter and Ruth Kerr)

Zinc

As well as lead, zinc was extracted from underneath the Dales. Calamine, an ore of zinc, was mined at Pikedaw Hill, near Malham, whilst Sphalerite, the chief ore of zinc, was taken from Grassington Moor.

Arthur Raistrick's 1947 book *Malham and Malham Moor* talks about the process of removing zinc from the dale. He said that there had been mines of copper and lead on the borders of Malham Moor towards Kilnsey Moor in the eighteenth century, but in the 1790s Pikedaw revealed calamine. He wrote:

> As news spread round about it came to the ears of brass makers. Brass had been made in England for over fifty years, the raw materials of the industry being copper and 'spelter' prepared from zinc ores. John Champion and others had developed the making of brass by using calamine direct, and there was great search for new sources.

Champion secured samples of the new zinc and came close to setting up a brass industry nearby in Skipton. It started a drive for the new substance and by the early nineteenth century Pikedaw and Grisedale were seeing calamine removed in large quantities. It 'was washed and calcined (roasted) on the Moor', continues Raistrick, 'and the Smelt Mill near Lower Trenhouse was used and altered for this purpose'. The ore would be taken into Malham for storage and then moved to Gargrave by horse and cart. Raistrick says the calamine industry was active for twenty years.